MANGA
MARTIAL ARTS

David Okum

IMPACT
CINCINNATI, OHIO
www.impact-books.com

About the Author

David Okum has worked as a freelance artist and illustrator since 1984 and has had comic book work published since 1992 when he had a story published in a *Ninja High School* anthology by Antarctic Press. He has since been included in two other Antarctic Press anthologies and several small press comic books. His writing and artwork have appeared in six role-playing books by Guardians of Order. He is also the author and illustrator of *Manga Madness, Superhero Madness, Manga Monster Madness* and *Manga Fantasy Madness* from IMPACT/North Light Books. David has also recently illustrated two graphic novels for Scholastic's Timelines series.

David studied fine art and history in university and works as a high school art teacher. David has dabbled in martial arts over the years moving from kung fu as a teenager to studying karate at the side of his daughters as an adult.

Dedication

This book is dedicated to all of the wonderful teachers in my life who have taught me everything I know.

Metric Conversion Chart

To convert	to	multiply by
Inches	Centimeters	2.54
Centimeters	Inches	0.4
Feet	Centimeters	30.5
Centimeters	Feet	0.03
Yards	Meters	0.9
Meters	Yards	1.1

Acknowledgments

I'd like to thank the following people for their help and contributions to help put this book together:

The wonderful martial arts instructors I have had the pleasure of personally learning from: Master Ron Day, Shihan Tammy Milne and Shihan Ken Verbankel.

Judith Bean, who graciously provided photos of her Japan trip to use as reference. Also I am deeply greatful to Sensei Stefan Barton and boxing great Fitz "the Whip" Vanderpool for their invaluable assistance in the research of this book.

My editors, Jeffrey, Wendy and Pamela for making my work look good.

Other fine IMPACT Books are available from your local bookstore, art supply store or visit our website at www.fwpublications.com.

12 11 10 09 08 5 4 3 2 1

DISTRIBUTED IN CANADA BY FRASER DIRECT
100 Armstrong Avenue
Georgetown, ON, Canada L7G 5S4
Tel: (905) 877-4411

DISTRIBUTED IN THE U.K. AND EUROPE BY DAVID & CHARLES
Brunel House, Newton Abbot, Devon, TQ12 4PU, England
Tel: (+44) 1626 323200, Fax: (+44) 1626 323319
Email: postmaster@davidandcharles.co.uk

DISTRIBUTED IN AUSTRALIA BY CAPRICORN LINK
P.O. Box 704, S. Windsor NSW, 2756 Australia
Tel: (02) 4577-3555

Library of Congress Cataloging in Publication Data
Okum, David
 Manga martial arts : over 50 basic lessons for drawing the world's most popular fighting styles / by David Okum.
 p. cm.
 Includes index.
 ISBN 978-1-60061-029-5 (pbk. : alk. paper)
 1. Comic books, strips, etc.--Japan--Technique. 2. Cartooning--Technique. 3. Martial arts in art. I. Title.
 NC1764.5.J3O485 2008
 741.5'3579--dc22
 2008019242

Edited by Jeffrey "The Juggernaut" Blocksidge
Designed by Wendy "Winnebego" Dunning
Production coordinated by Matt "The Machine" Wagner

TABLE OF CONTENTS

Disclaimer

Although the martial arts depicted in this book are real and every effort has been made to depict them in a realistic or authentic fashion, this book is not intended to be an instruction manual. It is a reference tool for manga artists, not a how-to book for martial artists. Attempting to duplicate the moves in this book without proper instruction or supervision from a qualified martial arts instructor is foolish and potentially dangerous.

Martial arts in manga and comics is dynamic, violent and flashy; more of a mystic plot device than an accurate depiction of reality. There is usually an emphasis on what looks cool over what is stylistically accurate or physically possible.

This book is designed to bridge the gap between style and substance, fantasy and reality. The basic elements of the individual martial arts are presented as a reference so that the artist can quickly understand the visual and theoretical differences between some of the most popular martial arts. Depending who you talk to, classical martial arts are traditionally linked to humans watching and analyzing the combat techniques of various animals: monkeys, apes or birds to name just a few. Over the years the techniques became formalized and even ritualized until they developed into a teachable series of actions that gave the practitioner an advantage in combat.

Conflict is the basis of all storytelling, and the promise of two people locked in mortal hand-to-hand combat is visually dynamic and dramatically stirring. Hopefully, this resource will help you think about drawing martial arts in a different way and allow your characters and plots to develop convincingly.

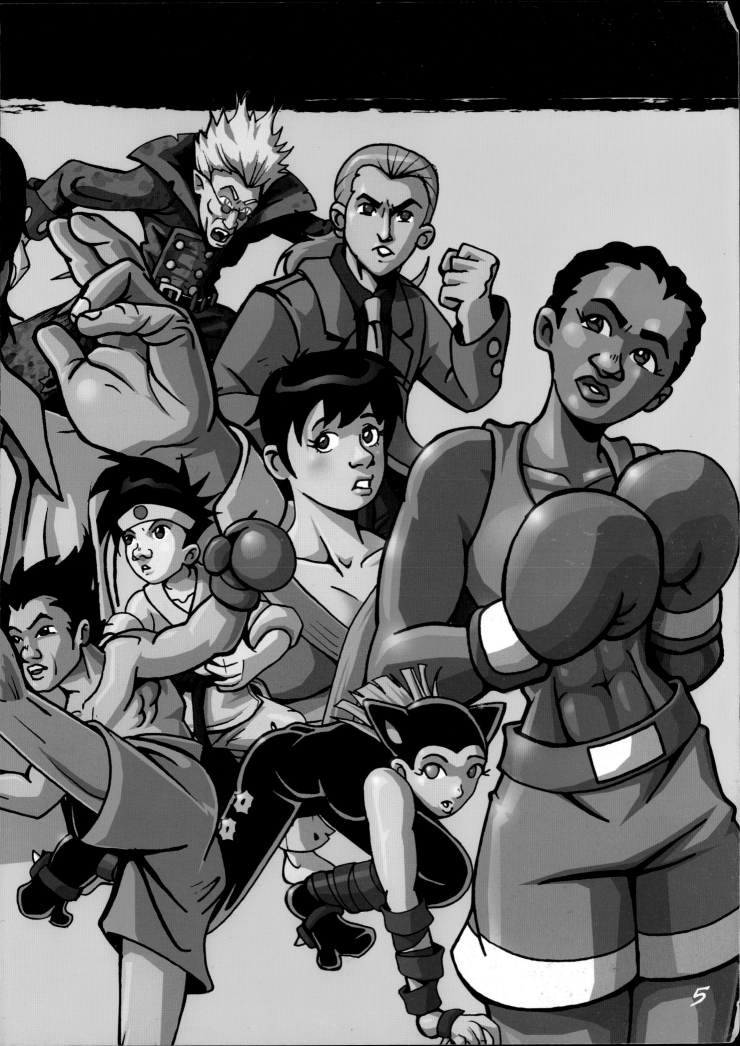

5

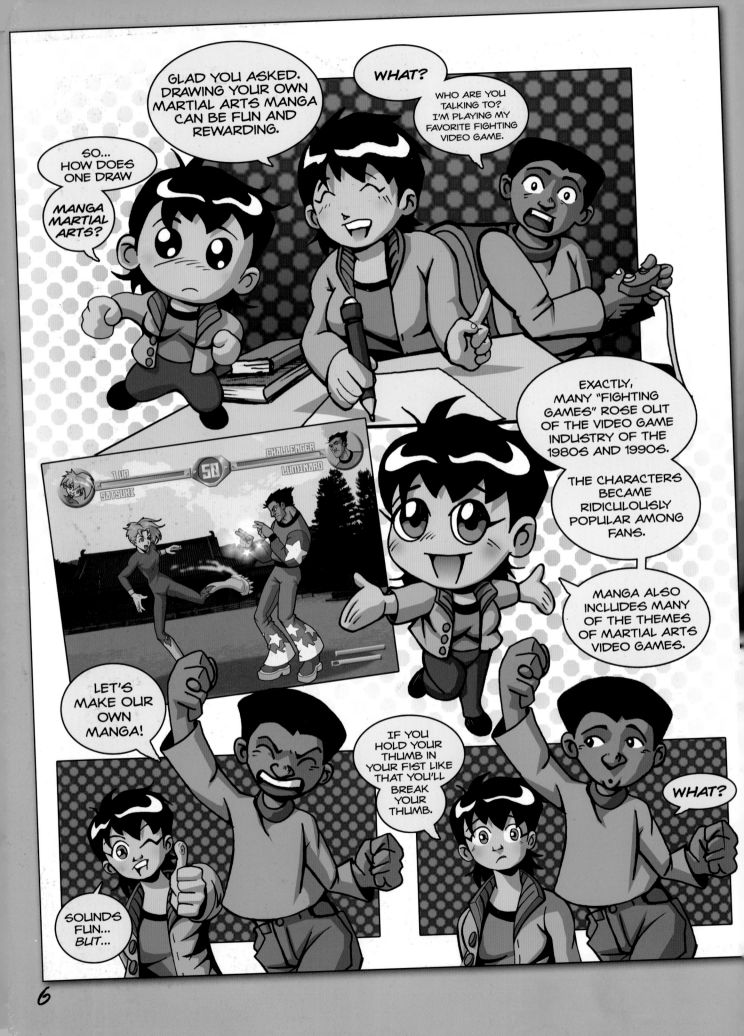

6

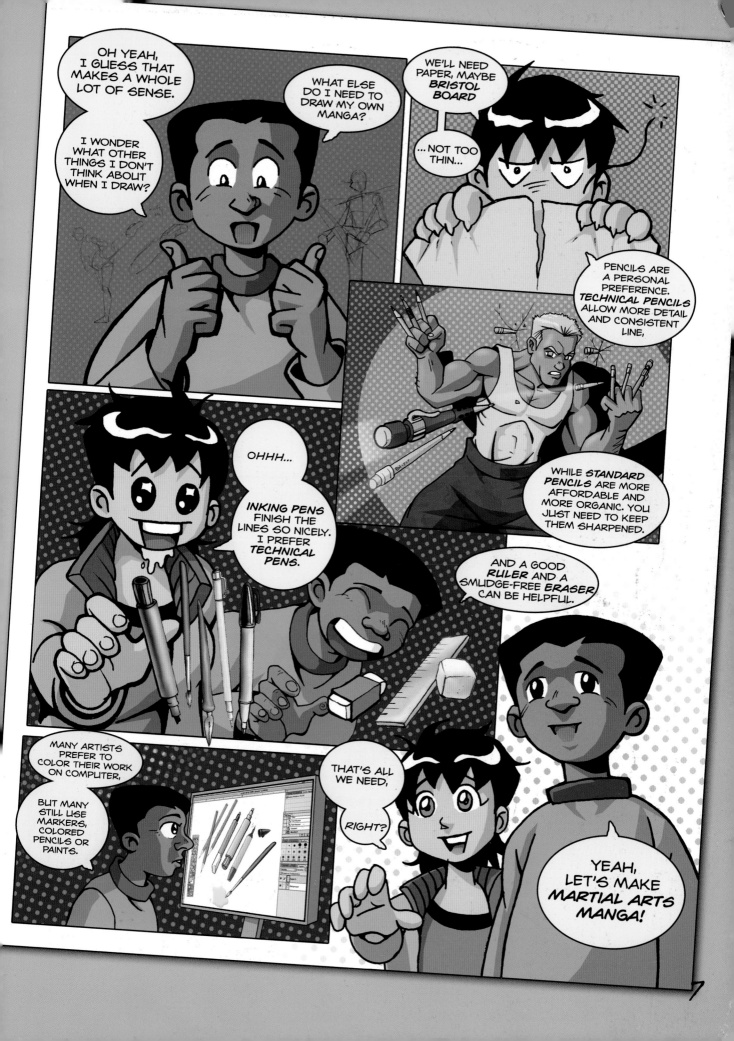

IT FIGURES

Martial artists are usually at the peak of human physical condition. The human figure can be very intimidating to draw, but don't worry. Break the figures down to the basic shapes. The human figure is just a collection of cylinders and spheres. Combine this concept with rules of anatomy, proportion and perspective and you will be able to draw anything you can imagine in a convincing way.

Use these guidelines as a starting point for drawing the human figure, but don't be afraid to exaggerate features to emphasize expression and character. People are much more interesting as individuals.

OUR HERO

The heroic adult male figure stands seven to eight heads tall. The shoulders are roughly three heads wide. Hands are about the size of the face from the chin to the eyebrows. The waist is roughly two heads wide. Males have a bulky upper torso. Male hips are as wide as the ribcage. Legs and feet should take up half of the total body height.

TEEN HERO

Younger characters have bigger heads in relation to the rest of their body. They will stand seven to seven and a half heads tall. This is a more realistic set of proportions. Younger characters also appear to have larger eyes and more expressive body language. Larger hands and feet also make the character appear more gawky.

FEMME FATALE

The heroic adult female figure also stands seven to eight heads tall. Even though the character may appear smaller than other characters, the head proportions remain the same. The neck is about one quarter of the head's height. Female hips are slightly wider and start somewhat higher on the figure. The wrists should begin at the halfway point of the figure.

KARATE KIDS

Kids are usually four and a half to five heads tall. The larger the head in proportion to the figure, the younger the character will appear. Again, the younger the character, the larger the eyes.

PUNCH DRUNK?

Watch the angle at which the figure stands. The head should rest in the area between where the feet are planted or the figure will appear off balance. This figure looks a little tipsy.

TWEEN HERO

Preteens and younger teenagers will be roughly five and a half to six heads tall. The feet and hands are larger in proportion to the figure, just like the head. The legs still begin halfway down the figure. It seems like they're still growing into their body.

INFINITE POSSIBILITIES

Alternate body types can play havoc on proportions and anatomy, but don't let that stop you from creating a wide variety of characters and body shapes.

Alternate Hero

Alternately a smaller hero can be less stocky and muscular. Anime, manga and video games have long traditions of these lithe martial artists.

DRAWING THE BODY

Muscles Simplified

Manga martial artists run the gamut from tiny rubber-limbed children to totally ripped muscle men. This leaves plenty of room for the manga artist to decide just how muscle-bound the characters can be. A sulking teen might be able to flip an opponent into the next block in some manga and find they are evenly matched with a weight lifter. The emphasis is on character design, not physical possibilities.

Biceps

Deltoid

Trapezius

Triceps

Latissimus Dorsi

Serratus Anterior

Ribs and Cartilage

Rectus Abdominis

External Oblique

Pectoralis

Quadriceps

Patella (knee cap)

Gastrocnemius

ACTION FIGURES

If you have an action figure handy that has the body type and proportions you are looking for, you can pose them any way you like as a reference for a drawing.

BASIC MUSCLE GROUPS

Be Resourceful

Keep a file of photographs as reference. That way you control the lighting, subject, angle and details. Some artists use computer software to create immersive 3-D environments and characters. They are able to manipulate the final image much more than a simple photo. Let your references fill you in on the issues of anatomy, proportion and foreshortening, but don't be afraid to take some creative license and make the final image as dynamic as you want. It's your drawing!

SUPER SIZE IT!

Rarely do anime and manga characters resemble the over-pumped hulks of western comics. Inflating the basic muscle groups to inhuman proportions could easily make a large cybernetic killer or an alien foe.

REFERENCE PHOTOS

Digital photography is a dream for this type of referencing. Jump, kick twist, roll, do anything that looks dynamic and cool; just be careful. In the creation of this image my arm took down an overhead light.

Keep It Simple

Remember to simplify the muscle groups and have fun creating an interesting character.

Creating Dynamic Tension

Accuracy is essential, but making the art look interesting and dynamic is just as important. Characters need to appear as if they are moving in real three-dimensional space, not sitting idle on a flat page. A drawing can come to life with the inclusion of foreshortening or low and high angles. Always avoid showing a character straight on. Mix it up and try to make every panel, every image, inventive and challenging. Dynamic views of two characters eating lunch can make the most mundane tasks appear as interesting as anything else that happens in the story.

Points of Dynamic Drawing

- Objects in the foreground overlap objects in the background.
- Objects that are closer appear larger and objects farther away appear smaller.
- Don't be afraid to leave things out if you can create a more dynamic and dramatic pose.

KEEP IT DYNAMIC

This is a much more dynamic way to show someone runnning than a side view and much more informative than of someone running away. The torso appears larger as it comes closer to the viewer.

FORESHORTENING

Try to use foreshortening to show objects coming out towards you, but also to depict the angle of the "camera." High-angle shots like this make the character appear smaller and less significant. The forced perspective of the hand makes it look like it's coming towards the viewer.

DRAWING THROUGH

This technique is used when part of the figure hides another part. It is particularly useful when drawing anatomy from memory. Block in all the shapes lightly and show the shapes behind the object, like the shoulder, arm and back visible through the head. Make sure your initial lines are drawn lightly so you know what's in the foreground and background. Capture the flow of action instead of focusing on detail.

LOW-ANGLE SHOTS

Low-angle shots like this make the subject appear more important or powerful than the viewer. Remember that the elements of the figure (the legs, arms, neck and torso) all appear to move back in space because they are drawn as three-dimensional forms, not flat shapes. Try to avoid horizontal and vertical angles within a composition. Use dynamic diagonals to make a drawing more interesting.

Aikido

Aikido was founded in the early twentieth century by Morihei Ueshiba who, after some martial arts as a child, studied an ancient form of jujutsu under Sokaku Takeda. Morihei spent six years of his life traveling through Asia and studying the spiritual beliefs of the esoteric religion Omoto-Kyo under Onisaburo Deguchi. In 1927 Morihei set up a dojo and began to teach an amalgam of the martial arts traditions learned from Takeda and combined these with the spiritual beliefs of Deguchi. Ai Ki Do literally translates to "harmony", "spirit" and "way." The goal was to harmonize the personal spirit with the spirit of nature. Aikido is thus a nonviolent martial art that attempts to use self-defense in a way that harmonizes with, as opposed to confronting, the opponent.

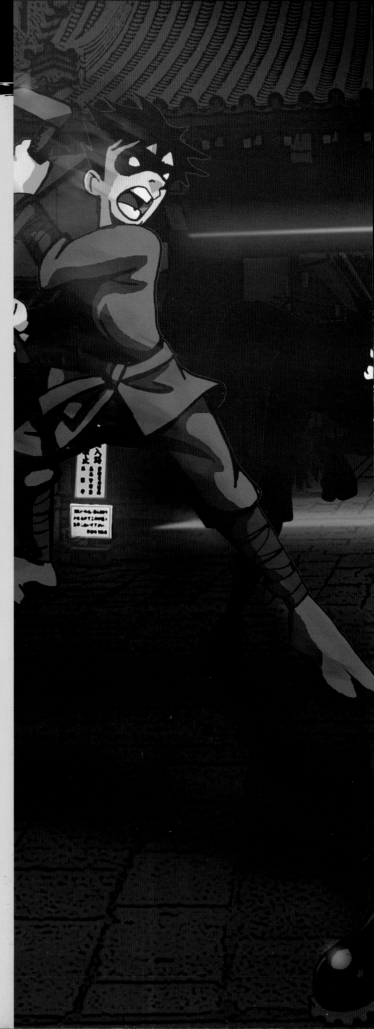

DEVELOPING MIND, BODY AND SPIRIT

Aikido attempts to develop the spirit as well as the body through important skills such as falling, concentration, alertness, breathing, strength and flexibility. Aikido also has very strict codes of etiquette regarding instructor respect and purity of the dojo. It's also important to respect Morihei Ueshiba (the founder of aikido) and display courtesy to fellow martial artists by bowing.

The Way of Harmony

Aikido attempts to create a harmonious response to aggression by matching and restraining the attacker. Almost all techniques rely on the opponent making the first move. The aikido practitioner may actually present a wrist or arm so that the attacker acts first. The idea is to use the opponent's energy, aggression and momentum to immobilize them rather than cause harm.

HANMI

This is the basic back triangle stance of aikido. The front foot should point forward and slightly outwards. The back foot should point out away from the body at a 60-degree angle. Knees should be slightly bent and the weight should be distributed 60 percent on the front leg and 40 percent on the back leg. The heel of the front foot should line up with the heel of the back foot as if you were standing on an imaginary line. Hands should be raised in defense from attacks and to present something for the opponent to grab.

This stance helps ground the practitioner, maintaining the figure's center of balance. The head is alert and centered above the area between the feet.

FOOT PLACEMENT

Place the feet as if the heels are standing on an imaginary line. This allows the practitioner to pivot and move in a natural way. The traditional hakama uniform does a good job of hiding the feet from the attacker, making it difficult to judge the defender's intentions.

Movement

Movement in Aikido should use circular footwork and pivots to avoid a temporary loss of balance. One of the first things to consider is moving away from the attack by matching the attack momentum and stepping aside. The next thing is to grab the attacker using hands, wrists and arms in order to stretch nerves and tendons and immobilize the opponent.

CONTROL

Grappling and wrist locks are designed to control the attacker. Using pain, joint manipulation and inertia control, an attacker is immobilized and rendered harmless. Here, a circular movement is used to gain control of the attacker and then a triangular movement is used to pin them to the ground.

USING MOMENTUM

What aikido lacks in offense it makes up for in defense. The idea is to match the movement of the opponent, remain grounded, wait until the attacker presents an opportunity to grab a limb, then gain control and put them on the ground in an uncomfortable hold.

THROWING

The most dynamic of all aikido movements are the uke waza throwing techniques.

KEYS TO THE WRIST LOCK

Key areas (highlighted here with red circles) are important in maintaining control of the hold. The elbow can be secured with the upper arm, the wrist is held in place by a strong grasp and the fingers are bent backwards. Simply pivoting the feet and rotating the body can send the opponent down.

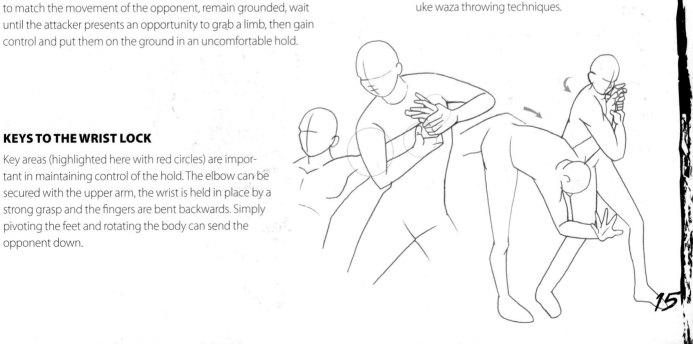

15

Entering Throw

For this technique the defender moves behind the attacker, turns to face the attacker's direction, pulls the attacker to the shoulder and strikes through, knocking the attacker to the ground. The side step avoids the initial attack and the counter attack uses a circular swoop with the right arm aimed just under the chin of the attacker in combination with a step through with the right foot. The attacker should become unbalanced and fall to the floor.

Women's Self Defense

This technique is often referred to as "women's self defense," not necessarily because it was meant primarily for women, but because the circular technique and use of the aggressor's force is effective no matter how small the defender.

1 SKETCH THE FIGURES
The attacker should be fully committed to the strike. If the defender steps aside too soon, the attacker might be able to change course.

2 BLOCK IN THE DETAILS
Make the forms as three-dimensional as possible. Consider, for example, that when you draw the sleeve the arm is a tube, not a flat shape. Keep your initial construction lines light so they may be erased easily. Clothing details should be settled upon and be consistent with each illustration of the character.

3 COLOR AND SHADE
When coloring and shading the final image try to remember that the forms are three-dimensional. If areas of black are shaded in they will disappear into each other. To define the individual forms, you need to indicate highlighted areas outlined on the clothing that show anatomical and clothing detail. To reinforce the darkness of the clothing, the highlights here are shaded blue.

First Form Throw

This is the first principle of arm pinning that is the foundation for other aikido techniques. An overhead strike is blocked by both hands that intercept the attacking arm in a smooth, flowing motion. The arm is then twisted and turned, flipping the attacker to the floor.

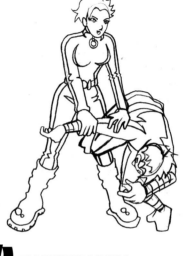

1 SKETCH THE POSE
The pose depicts the point of the defense where the attacker is flipped to the ground. The attacker should appear to have rotated fully to match the twist of their arm and shoulder. The hands of the aikido defender are level, the stance is solid and grounded.

2 BLOCK IN THE DETAILS
Erase the construction guidelines as you block in details. Remember to differentiate similar colored objects with highlights that reveal individual form, details and anatomy.

CIRCULAR AND FLUID

The initial instinct would be to draw the defender striking the attacker's arm as the strike is intercepted, but the movement should appear circular and flowing, not stiff and static.

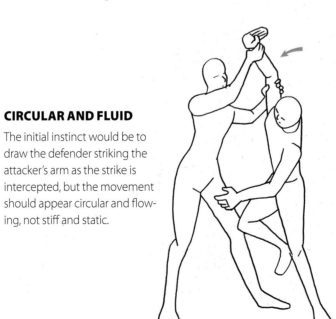

3 COLOR AND SHADE
Color and shade with a sense of cast shadows and highlights. If you imagine where the light source is in the drawing (in relation to the figures), it's easier to remain consistent. When depicting the grappling martial arts, it's a good idea to make each combatant's skin color slightly different so that you can tell which arm is which.

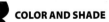

Wrist-Out Turn

Kotegaeshi literally means "wrist-out turn." This is a basic technique where the defender grabs the back of the attacker's hand, applying pressure inward to stop the power of the attacker's arm and wrist, and outward to knock the attacker off balance and cause them to fall down.

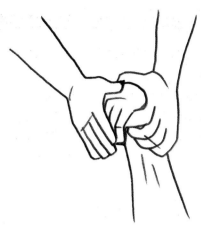

CLOSE-UP OF HAND PLACEMENT

Notice how the attacker's wrist is twisted back toward them and the fingers are pushed down to the wrist. This stretches the tendons and nerves and immobilizes the opponent through pain and physical restraint.

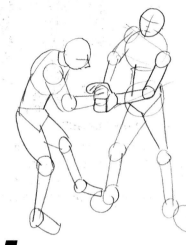

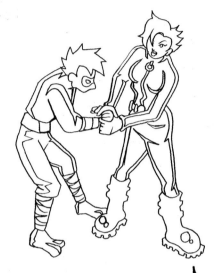

1 SKETCH THE FIGURES

This pose shows the stage in Kotegaeshi where the attacker's wrist and arm have been locked and brought down in between the attacker and defender. Keep the shapes loose and explorative. Make sure that the feet are placed so it appears that the figures are standing in a physical space and that they are well balanced and stable.

2 CHOOSE AND ADD DETAILS

Carefully choose the details that make sense as you clean up your drawing. A look of calm on the defender's face is preferable. The attacker will probably appear to be in a lot of pain from the wrist hold. Erase extra pencil lines.

3 COLOR AND SHADE

As you color the final image make sure to keep the characters distinct by making sure their skin tones are slightly different, that they have contrasting color schemes (in this case warm vs. cool colors) and have details (such as dark hair vs. light) that make them quickly identifiable.

CONTINUE THE CIRCLE

Flipping the attacker onto their back requires stepping through with the left leg. Make sure the hand is still firmly grasping the wrist. Continuing the circle by moving the left leg and pushing the hands downward in the same direction of the leg will cause the attacker to roll on their back.

Back Technique

Aikido is ultimately a self-defense martial art. Attacks from behind are as effectively neutralized as those from the front. The defender uses the inertia of movement to unbalance and ultimately turn the tide in this situation. This defense reinforces the movement of circular footwork, matching momentum and grappling.

KNOCKED OFF BALANCE

From another angle you can see how the attacker has been knocked off balance and the defender has set up a number of counterattacks ranging from a wristlock to a knockdown.

1 SKETCH THE FIGURES

Depict the figures as individual simplified forms. Differentiate each combatant from the other. Notice the wide stance of the defender. By moving their left leg back and under the attacker they have dropped very low. Moving forward and flinging the arms out breaks the grab and also knocks the attacker off balance.

2 DEFINE THE FORMS

Clean up the lines and define the individual forms to separate each figure. Erase the guidelines.

3 COLOR AND SHADE

Color and shade to show the shadows and highlights of each figure. It's important because of the close-combat grappling and that they are both wearing black. Different color highlights help keep your characters sorted out.

UNIFORM AND EQUIPMENT

The standard uniform for aikido students is a basic white gi, much like any other Japanese martial arts such as karate or judo. Adult students do not wear colored belts. When students pass their first black belt exam or shodan, they earn the right to wear the hakama, a traditional black divided skirt.

Samurai Tradition

The division and pleats of the hakama can be seen more clearerly in this illustration. The hakama was originally a traditional piece of samurai clothing made of heavy cloth and worn like chaps when riding on horseback.

HAKAMA

Earning the right to wear the hakama can take four to eight years depending on the skill and dedication of the student. Some dojos award the right sooner, based on their specific traditions and the work ethic of the individual student. Women were often allowed to wear a hakama from the outset because a gi was often considered to be underwear and modesty demanded that underwear be covered.

HIMO

The hakama is tied with an attached fabric belt called the himo. The himo is tied on the front and the back in two small bows that are then tucked into the hakama. You wouldn't want anyone reaching out and untying them. There are seven pleats in the hakama, two in the back and five in the front. The pleats are often symbolic of the budo virtues valued by the samurai: benevolence, honor, courtesy, wisdom, sincerity, loyalty and piety.

BOWING

Aikido is a martial art full of respect, strict tradition and etiquette. Students bow together to fellow students as a sign of mutual respect. The bow is also used when entering the dojo (training center) and it is directed to the location of the instructor. The founder of aikido, Morihei Ueshiba is traditionally depicted at the front of the dojo in a specially reserved and revered place. Students bow to the photo in respect for aikido's founding and traditions.

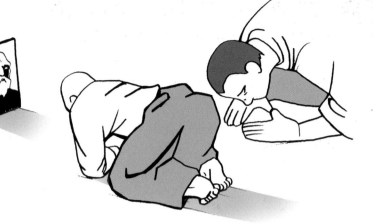

THE TANTO

Students practice self-defense techniques using a wooden knife called a tanto. The tanto is not sharp and is an excellent training tool for redirection and disarming techniques.

THE JO

The jo is a traditional quarter staff and it is an excellent training tool for maintaining posture and arm strength in unarmed encounters.

THE BOKKEN

The bokken is a wooden sword, roughly the same size and shape as a katana (Japanese sword). Weapons in aikido are used as extensions of the practitioner and complement the training and techniques of unarmed combat.

Boxing

Fighting as an organized sport has existed for thousands of years. There is evidence from Egypt as far back as 3000 BCE. including a pottery relief of a cat and mouse bout refereed by an eagle. Mediterranean Minoan cultures depicted boxing in wall paintings from 1500 BCE. The ancient Greeks and Romans also had boxing, but used hardened leather strips to protect the hands instead of boxing gloves. Matches ended in knockout, surrender and sometimes the death of the opponent.

Bare-knuckle boxing contests adopted a set of rules around 1743 to help avoid severe injury and death. In 1865 John Sholto Douglas set down the rules of what we would recognize as the modern sport of boxing. He included timed rounds and the use of approved boxing gloves. In 1904 boxing was included in the Olympics and developed into the modern sport we know today with regulated codes, rules and conventions.

FLOAT LIKE A BUTTERFLY, STING LIKE A BEE

With those immortal words, Muhammad Ali, arguably the twentieth century's greatest professional boxer, described his signature style. A mixture of measured grace and devastating power goes a long way in the boxing ring. Boxers don't just stand in one spot and trade punches. A boxing match is more like a dance where two combatants test, measure and eventually pummel each other.

Boxing Manga

Boxing manga is a specific, but exciting subset of manga devoted to heroic depictions of sports and athletes. Tomorrow's Joe is a good example of a popular manga and anime devoted to boxing. The death of Joe's greatest rival in 1970 drew over seven hundred people out to a funeral for the fictional character. The show is still a huge cult favorite in Japanese culture, often near the top of lists of favorite TV anime shows.

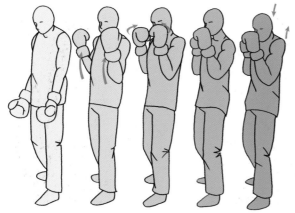

ASSUMING THE STANCE

Set the legs as wide as the shoulders to provide stability. Place the right foot back a half step behind the left foot (if the boxer is right-handed) with both feet pointed slightly inward. Raise the right (or back) heel to allow the fighter to pivot. Bend the knees slightly, lowering the body.

BALANCED IN DEFENSE

Maintaining a defensive posture, the boxer leans forward and back, balancing on the ball of the rear foot, ready to strike.

RAISING THE ARMS

Raise the arms up to the chin and twist the wrist so the knuckles are vertical in relation to the floor. Place the left hand slightly forward about six inches in front of the face at eye level. Place the right (rear) hand beside the chin and the elbow of the right arm along the body to protect the ribs. Finally, lower the head and point the chin down to reduce the chances of taking one in the jaw.

Movement

Constant footwork maintains a level of intensity and energy in the boxer and keeps the opponent guessing. Good footwork will propel the punches and add power to a strike.

LEFT CROSS

The left cross punch is thrown from the chin by the rear hand. The shoulder comes forward as the striking arm crosses the torso and pushes forward. The torso and hips twist to add power and weight moves from the rear foot to the front. This strike leaves the attacker quite vulnerable until the arm is brought back for defense. It often follows a quick jab.

FOOTWORK

When the time is right to throw a punch the boxer steps forward with the lead foot. Putting a half step into the strike adds the momentum and weight of the boxer behind the punch. Keeping an eye on the shoulders of an opponent allows a boxer to set up a reasonable defense, whether it be a block or an evasion.

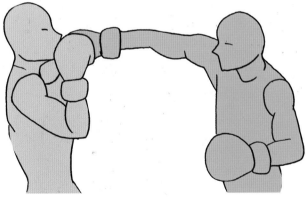

PROPER GUARD POSITION

In proper guard position the face and ribcage are protected. Here, the glove is tight with the chin and the force of the impact is soaked by the body. The head has been snapped back by the impact. Make sure that the head appears to be tucked down when the target is about to be hit.

Guarded Body

Don't forget to make sure the glove guarding the face doesn't appear too far away from the chin. If it's too far, it will still strike the chin when hit. Draw the elbows close to the body so they can defend the ribcage.

25

The Jab

The most basic of all boxing punches and the least powerful, the jab is mainly used to feel out the opponent, to set up a cross or a hook. The leading arm should be level to the guard position and the fist should rotate so that the hand is facing down and the knuckles are horizontal. The rear hand stays back to defend the chin and the hand should snap back to defend against a counterstrike.

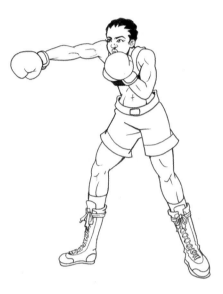

1 BLOCK IN THE POSE

Quickly and loosely block in the pose using basic balls and sticks. Tubelike thickness has been added to the arms and legs to reflect the mass of the muscle and bone. Keep the elbow close to the body and the back fist close to the chin.

2 ADD DETAILS

Flesh out the basic stick figure. Clothing and equipment details might require the use of a reference image. Draw lightly; these construction lines will be erased in the final drawing.

3 CLEAN UP AND INK

Clean up the extra pencil lines that can be messy and confusing. Simplify complex details such as the hair and boot laces so that the image is not too detailed in some areas and simplified in other areas.

4 COLOR AND SHADE

Maintain the illusion of three-dimensional form by considering that the figure is lit by a consistent light source. Place areas of shadow and highlight based on the direction of the lighting. Many boxers have carefully chosen, color-coded clothing to add to their professional image.

The Hook

The hook is usually thrown with the lead hand. The elbow rises and the fist arcs across horizontally as the figure rotates the hips to reinforce the direction of the punch. The lead foot twists with the body as well and the toes will point in towards the boxer's body. This strike is meant to hit the side of the head. If lower, it can hit the jaw, ribs or impact organs such as the liver.

1 BLOCK IN THE POSE

The direction and structure of the figure are the most important at this phase. Keep the lines simple and organized. Some lines, such as the lines that illustrate the direction of the shoulders and hips reveal a figure that is twisting in space and is not a flat form.

2 ADD DETAILS

Details are added and the extra lines are cleaned up. Remember that the figure is made up of tubes and balls and that the striking arm should appear to be moving back in space and appear to be coming toward the viewer at the same time. The eyes have a wild killer instinct. That's helpful when you fight for a living.

3 COLOR

Erase rough construction lines and carefully shade and color the final image. If you like, logos can be added to the spaces left blank on the shorts and the gloves.

First Movement

This image shows how the hook begins, with the elbow drawn back and the fist raised horizontally. It looks awkward, but the hook can be a devastating punch. Coming in from the side it can be quite a surprise as well.

The Uppercut

The uppercut uses the rear hand and drives upward along the center line of the target, aiming for the chin or upper body. This can be a difficult punch to execute because it opens up a defense and takes time to perform. The benefits of this punch are that the defender's gloves will be knocked aside and will be less of a defense for the chin. It is also a difficult punch to see coming as it travels from below the field of vision and is often obscured by the gloves up in defensive position.

1 BLOCK IN THE BASIC FORMS OF THE FIGURE
It's important to understand the direction the knuckles are facing before the details of the glove are added. The arm should drive up and the body should push upward quickly. The hip should twist anticlockwise as the rear heel twists out, adding to the force of the strike. This attack is devastating on its own, but it should also be able to straighten the opponent and set up future attacks.

2 CLEAN UP DETAILS
This allows you to draw important details of the figure's pose and clothing. Erasing the preliminary pencil lines at this stage creates a crisp, less confusing image in the end.

3 COLOR AND SHADE
Complete the intensity of the pose with color and shading. Make sure that you consider the fact that the figure is three dimensional, not flat when you shade it. To show greater speed or power you may want to draw movement lines from the glove or draw it blurred on the edges.

The Knockout Cross

The basic cross is thrown from the rear hand and the entire body twists anticlockwise as the cross is thrown. The body weight shifts from the rear foot to the lead, adding the weight and twist to the power. This punch is shown from a more dynamic angle and is much more exaggerated than the other, but it shows how speed lines create movement and describe the path of the punch.

Don't Overdo Speed Lines

Use them for dramatic effect when the punch is meaningful to the story.

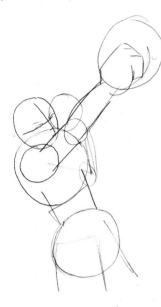

1 BLOCK IN THE PUNCH

Remember the basics of construction drawing and foreshortening. The arm should appear as a three-dimensional tube, not flat. Part of that illusion is to draw it as a cylinder at this stage so that when details are added they conform to that shape.

2 DRAW FINAL LINES

As you are drawing in the final lines be very aware of the weight of the lines. Heavy lines appear closer and also have a greater sense of weight and form. Thin lines can help indicate highlights and objects that are further back. The movement lines add to the sense of action and energy.

3 COLOR AND SHADE

This is a powerful punch, but you can see how it sets up the attacker for a wicked counterstrike. The attacker should really be sure this will stagger their opponent or the tide of the battle could turn, fast. This kind of punch also wears down the attacker quickly. Tired boxers forget to defend themselves.. A big part of the strategy of boxing is tiring out your opponent and conserving energy to go round after round.

29

UNIFORM AND EQUIPMENT

Boxing promotes safety and proper training. In the past, bare-knuckle brawls turned into bloody, unpredictable and often deadly confrontations. Today, there is a strong emphasis on protective equipment such as gloves, helmets and mouth guards. Diligent refereeing enforces the strict code of conduct during a match. Boxing is very dramatic to chronicle in manga because of the hard-working dedication, harsh training and heroism of the boxers.

The Grand Entrance

Part of the mythology of boxing comes with the boxers' dramatic entrance as they are announced and climb into the ring, dressed in robes.

UNIFORM

Traditional boxers wear laced boots to grip the ring surface. Shorts are often colorful and may have the name or nickname of the boxer emblazoned upon them. As a boxing match wears on, it helps if both boxers are wearing different colored shorts to help tell them apart. A long robe or towel keeps the boxer warm and stops the muscles from seizing up after an intense workout.

BOXING GLOVE

The boxing glove is standard equipment for modern boxing. It protects the hands and spreads out the impact of the punch. The hands themselves are wrapped with strips of cloth to support the wrist and knuckles and to protect them from fracture and nerve damage. A trainer or assistant laces up these gloves to ensure they are secured.

VELCRO VS. LACED

Velcro gloves are used primarily in training. The boxer can remove these gloves without assistance. This could be dangerous in a real fight. Which is why the gloves are always laced for a serious match.

HEAVY BAG

Large, heavy bags filled with sand condition the boxer to execute powerful punches on an actual target.

SPEED BAG

Small, ceiling-mounted punching bags or "speed bags" allow the boxer to practice fast punching and accuracy.

RING

Boxing matches are conducted in a square ring. It is generally a raised platform with four parallel rows of ropes attached to turnbuckles. The turnbuckles are attached to posts on each corner of the ring.

Capoeira

African slaves created capoeira in Brazil over five hundred years ago. Forbidden to carry weapons or study self-defense, they did their technique and training in something that resembled an elaborate ritual dance.

The movements and music originated from African dances and the art was a creative and practical way to pass on African cultural practices of music and dance.

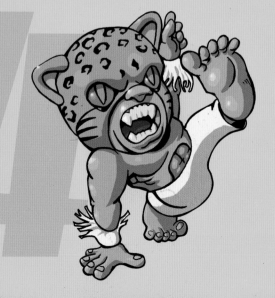

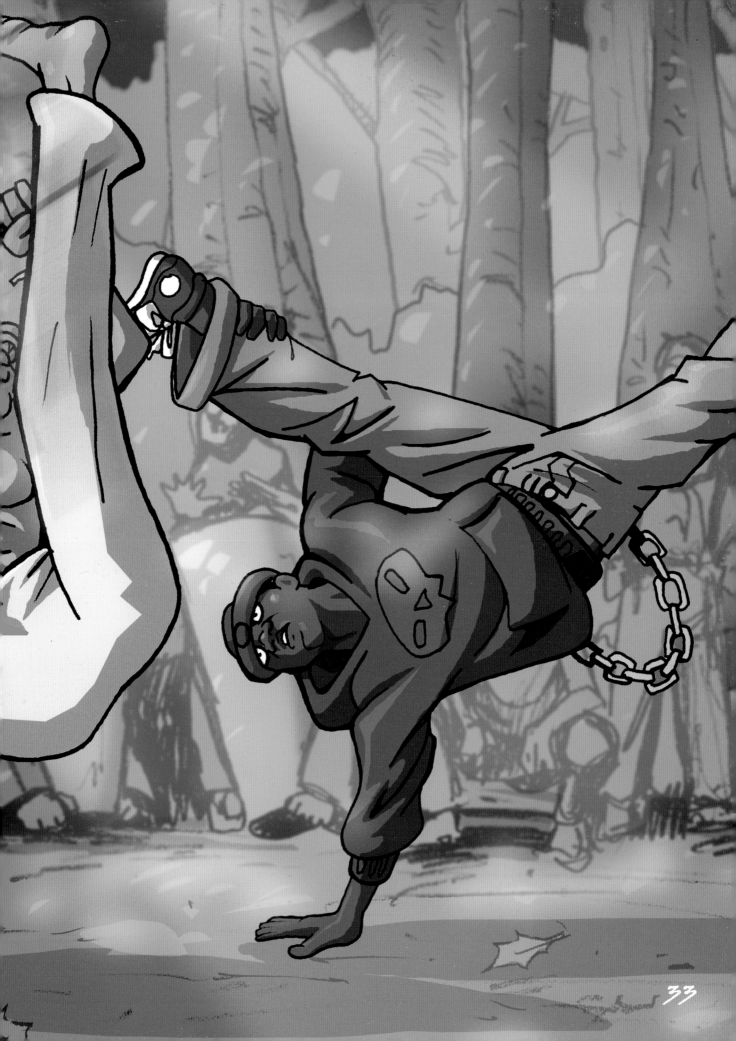

A DANCE OF THE SLAVES

Capoeira artists greet each other then cartwheel into a circle of musicians, spectators and fellow contestants. Musicians play songs about everything from legend and history of famous battles to funny stories and tales of lost love. The songs inspire the artists, entertain the onlookers and also pass on a traditional oral and cultural heritage.

The Art of Positive Support

Capoeira is essentially practiced as a game between opponents, usually in a positive and supportive way. The purpose of the "game" of capoeira is to express and develop skill and technique. Strikes are not necessarily intended to connect, but are part of a complex "call and answer" approach to practicing maneuvers and exhibiting restraint with ability.

DYNAMIC VISUALS

As with any acrobatic martial art, jumping and spinning are depicted to heighten drama and provide dynamic visuals. Use detail to reveal information in a drawing.

BALANCING THE CAPOERIA FIGURE

The key to solid balance is a low center of gravity and lining up the head with the weight-bearing foot.

Movement

The ginga is the basic "stance" of capoeria. It is a loose rocking from side to side with a swinging motion that allows the practitioner to launch into almost any movement or action, offensive or defensive. It appears inherently dancelike and is timed to the rhythm of the accompanying music.

THE SPIRIT OF CAPOERIA

You may want to look at contemporary urban hip-hop or freestyle break-dance moves, many of which owe a great deal to the spirit of capoeria movement technique with dynamic sweeping movement.

MOVEMENT

Draw the ginga stance crouched forward and low. This allows the martial artist to keep out of the way of kicks, and spring into almost any action.

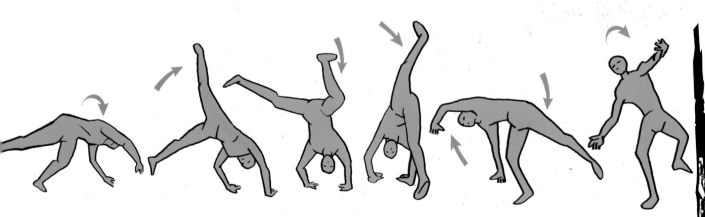

THE CARTWHEEL

The cartwheel is the basic method of movement in capoeira. It is traditionally how the players enter the circle to begin their game. When drawing the cartwheel, consider what stage of the movement is the most dramatic or appropriate for the story.

The Cartwheel

This is the most basic movement in capoeria. In order to enter the roda (circle of people) each participant must cartwheel into the center. Some acrobatic kicks are based on the cartwheel, but hitting someone while executing a cartwheel can send the attacker careening out of control. A cartwheel kick lacks accuracy and is easy to dodge.

Flipping Out

Confident capoeria fighters can even perform handless cartwheels. This eliminates the possibility of a foot sweep knocking them down as they move around and it looks pretty cool too.

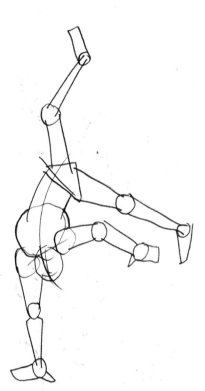

1 BLOCK IN THE FIGURE
Use the basic shapes and forms of the body. Make sure the figure looks like they are in movement and not just bouncing around on one hand, although that looks like fun.

2 DEFINE THE DETAILS
Clean up the lines and be aware of the direction of movement that you are describing. That means that the clothing should move away from the direction of movement. Pant cuffs should hug the leg as it rotates.

3 COLOR AND SHADE
Indicate areas of detail including creases and folds in the clothing that help describe the pose and the movement. Refer to real clothing to see how it responds to this kind of pose. If you are drawing a capoeria character, this is a common movement you will have to get used to drawing at various stages and angles.

Armada Spin Kick

This kick uses the weight and momentum of the leg to launch a high kick at the opponent. The Armada pulada is a jumping form of this powerful kick. Getting off the ground is an important benefit of this kick as your opponent might choose to trip you with a leg sweep or rasteira (see page 38). The sheer force of this attack makes it almost impossible to block without being knocked down. This move characterizes the wide range of levels that capoeira addresses: acrobatic high jumps and devastating kicks as well as crafty ground work.

1 BLOCK IN THE FORMS
Remember your proportions. One of the easiest errors to make at this stage is to make one leg longer than the other or mess up the length of the arms. One way to solve this problem is to "draw through," that is imagine that the initial drawn forms are three dimensional and transparent. That way you can see that you haven't made an error even if an arm or a leg overlaps the anatomical detail.

2 CLEAN UP THE FINAL LINES
Erase the initial "blocking in" marks. Show the effect of movement on details such as clothing. Folds and creases in cloth will overlap each other and define the form underneath. Make sure that the final lines vary from thick to thin to help describe the weight and form of the figure.

3 COLOR AND SHADE
Suggest detail such as folds, creases and anatomy through shading. Details are stylized and simplified. Don't be afraid to use real references to see how clothing folds, creases and stretches.

Rasteira

Rasteira is a foot sweep designed to trip your opponent. It is usually a countermove to a high kick. The target should be committed to the strike and be unable to defend themselves from the trip.

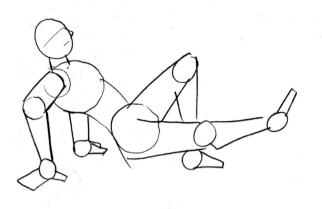
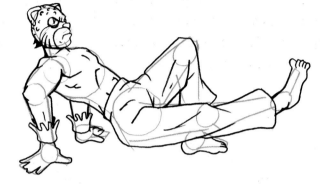

1 BLOCK IN THE FORMS
This is an awkward pose to depict. The figure has dropped to the ground in a "crablike" pose, supporting their weight on the hands and legs. One leg is extended to sweep the opponent's legs out from under them or to hook and pull. When this is done quickly, the opponent may be surprised and find they are unable to move out of the way. Notice how the legs are "drawn through," allowing you to see where each leg should go in relation to the other.

2 CLEAN UP THE FINAL LINES
Consider the effect of the shifting of weight and the stretching and compression of bone and muscle when you add details such as clothing. The pant leg is moving away from the direction of movement.

3 COLOR AND SHADE
Finalize the image carefully, placing areas of shadow and highlight to help define the form of the figure. The color of the pants is white, but few objects in space are truly white. Many reflected colors and shadows make most whites appear to be gray.

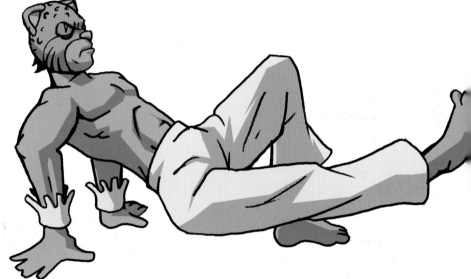

Kip-up

Deceptively simple in appearance, the kip-up is a difficult move to master, but it allows you to launch from prone to standing in a matter of seconds. It is an impressive move, more recently associated with break dancing and hip-hop. It requires strong abdominal and shoulder muscles and an excellent sense of balance. When leaping to your feet you are literally using the weight and momentum of your legs to propel your upper body forward and up. The legs are tucked under the body and your arms push you forward.

Catapulting the Body

As you can see, the legs go toward the head and the hands are firmly planted on the ground. The back arches up and the legs are quickly tucked under the torso. This action catapults the body forward using the momentum of the legs to pull the torso with it.

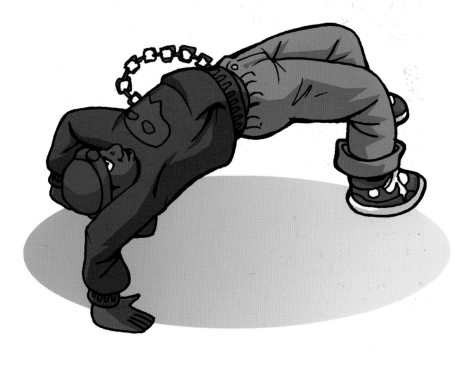

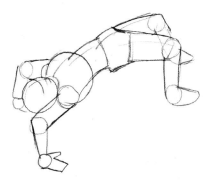

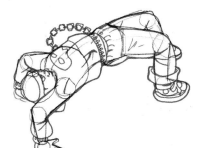

1 BLOCK IN THE FORMS

This is a very awkward pose to draw. One of the first things you have to decide is which is the best stage of the maneuver. This image depicts the figure just as the weight is thrown forward. Keep your exploratory lines light so they can be easily erased.

2 CLEAN UP THE FINAL LINES

Reinforce the direction of movement by depicting details such as the pocket chain moving in the opposite direction of the figure. The figure should appear to be a coiled spring, not a limp noodle, so make sure there is lots of tension in the figure and lots of creases in the clothing.

3 COLOR AND SHADE

Finish up the image by blocking in the areas of color and value. The shadow cast on the ground helps to give the figure context. The image should appear to be an acrobatic move frozen in time, not writhing on the floor.

UNIFORMS AND EQUIPMENT

Capoeira was created by an impoverished people. They also had to disguise their martial art as a game or dance. Therefore, uniforms are very basic with most of the attention focused on the instruments used to make music for the "dance."

Student

Graduated Student

Professor

Conte-Mestre

First degree master

Second degree master

Third degree master

Grand master

WHAT TO WEAR

The basic capoeira uniform consists of white cotton pants and a cord or rope to hold them up like a belt. Female fighters wear a top and depending on the climate and traditions, so may the men.

Capoeira Angola

Capoeira angola is an earlier form of capoeira and is noted for the distinctive modern uniform of a yellow T-shirt, loose black pants and running shoes.

THE CAPOEIRA CORD

The capoeira cord is a simple rope used to denote belt level for capoeira fighters. Individual ropes are entwined with others to form the color system based on the colors of the Brazilian flag. The most basic cord is a plain green for a "baptized" student.

Red Cords

In some more traditional Brazilian schools, red cords are often given to masters (mestra). After ten-to-twenty years the master would wear a white and red cord, then graduate to white after another twenty years.

THE RODA

The roda is a circle of people who clap and sing with music played for the two capoeira players who perform acrobatic moves and kicks in the center. The participants may join in the center with a complex ritual that allows them to take part in the game. Capoeira players often don't hit each other on purpose, but instead demonstrate their moves and kicks in an attempt to show up their opponent.

MUSIC

Music is a major aspect of capoeira and sets the pace and tempo for the players. Since capoeira was one way of maintaining an African heritage, the music had a cultural, social and spiritual role. Drums such as the conga (depicted at right) are used to keep the beat and drive the action. Traditional capoeira employs complex rituals and song patterns. Modern players sometimes use recorded music to practice or simple clapping from the circle (roda).

OTHER INSTRUMENTS

The berimbau is a single metal stringed "bow" with a round, hollowed-out gourd to amplify the sound. The caxixi is a small rattle held in the same hand as the stick that strikes the berimbau's steel string. A small stone or coin is pressed on the string to modify the pitch.

Pandeiro are tambourine-like instruments. In more dangerous times, the metal rings of the pandeiro were sharpened, allowing the instrument to become an impromptu weapon.

Literally translated as "the gentle way," judo evolved out of jujitsu as one of the most widely distributed martial arts sports in the world. Judo seeks to use the bodyweight, strength and momentum of the opponent against them. Strength, force and training are often no match for tactics, ability and practice. More than just a grappling sport, judo emphasizes the spiritual development as well as the physical. Jigoro Kano, the founder of judo, wanted the practitioner to "perfect oneself and contribute something worthwhile to the world," noble aspirations, indeed.

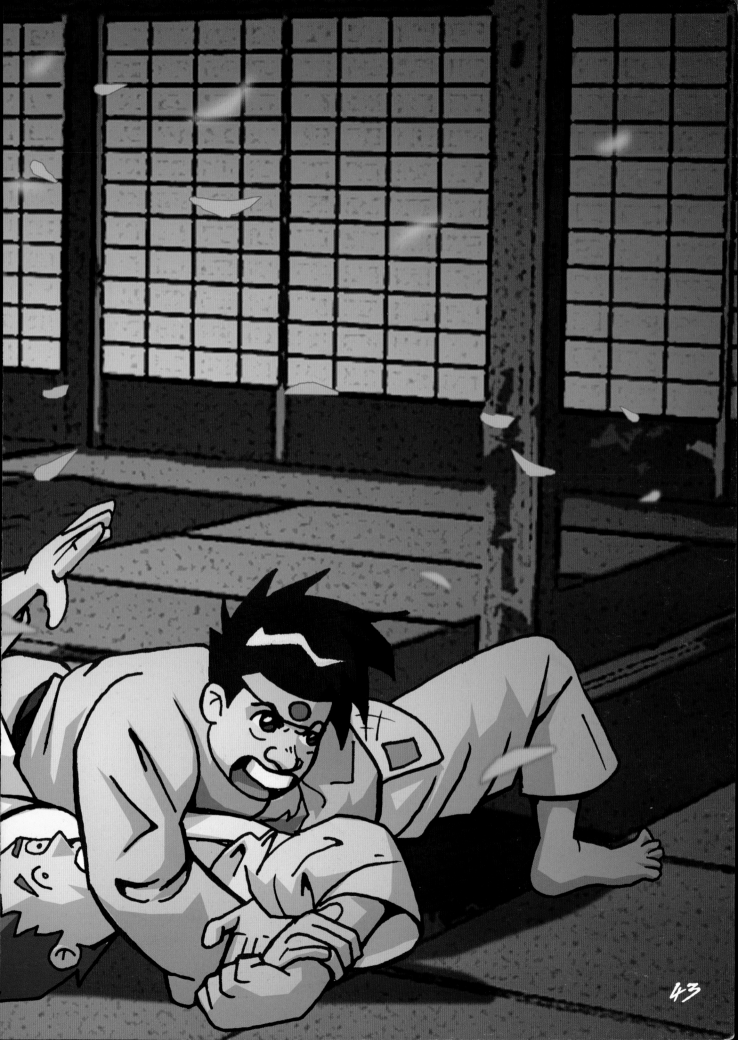

THE BIGGER THEY ARE, THE HARDER THEY FALL

Judo is an excellent self-defense system because it focuses on redirection of offensive strikes, self-defense and restraint, not injuring the opponent. Because personal size and weight are not as much of an issue, it is also a popular martial art for women and children.

Etiquette

Etiquette is important in judo ensuring courtesy and respect towards the opponent, but it also ensures that everyone is safe. The bow is a traditional sign of respect, but make sure there is enough room between the characters in your drawing, you don't want them to bump heads. Ouch!

STANCE

Judo stance is what is known as a "ready stance." The knees are slightly bent, the head is held up and the torso is bent slightly forward. The feet are placed less than shoulder-width apart and turned out at a 45-degree angle with the heels lined up. The arms should be held relaxed at the side and the hands can be in a fist or relaxed.

CORRECT SITTING (SEIZA)

Personal development and spiritual growth are important founding principles of judo. The seiza (literally, "correct sitting") position is the traditional formal way of sitting in Japan. Seiza should be executed thoughtfully and with respect.

Movement

One of the important skills learned in judo is the art of breakfall. Knowing how to break a fall properly lessens the chance of injury when practicing throws. Throws require the defender to move into the attacker's center of gravity, break their balance and use their own weight and momentum against them.

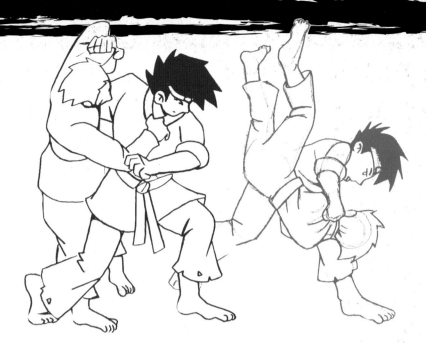

A SUCCESSFUL THROW

The elements of a successful judo throw are: dropping below the opponent's center of gravity, secure grappling, leg sweeps or trips and using momentum and body weight as leverage. Someone who doesn't know how to fall could get seriously injured.

HIP THROWS

Getting under the opponent's center of gravity makes it easier for a smaller person to throw a larger person.

BREAKFALL

Practice and drills also make breakfalling second nature or instinctive. The trick is to roll with the fall and spread out the impact by extending an arm.

ARMLOCKS AND PINS

Armlocks and pins can be very painful. The opponent's ability to break free or even move is limited. Slapping the floor is a sign of surrender. A contorted face also sends an obvious message.

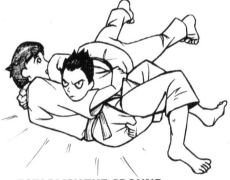

ESTABLISH THE GROUND

Drawing groundwork is important to establish the actual ground. Without the impact lines here, it appears as if one person is carrying another through the air. These action lines can define the force of impact in a battle.

45

Breakfall

One of the first things learned when studying judo is how to fall properly. Practicing falling avoids countless injuries during training and provides a valuable skill to the student of judo. Ukemi requires a relaxed body and the ability to roll with the throw or fall. This, combined with an outstretched arm evenly distributes the impact. Make sure you draw the figure with a chin tucked in close to the chest to avoid whiplash.

Slap!

In the judo dojo the sound of students slapping to the ground from falls can be deafening during class.

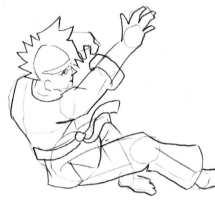

1 BLOCK IN THE FORMS

A falling figure looks out of control at first, but closer inspection will reveal that the figure is taking precautions to avoid injury. When drawing the figure in a complex action like this, "draw through" the figure, showing the arm and leg through the head, limbs or torso. This allows proper placement of body parts in the drawing and avoids distortion.

2 CLEAN UP THE FINAL LINES

When details are added, it's easier to see how the figure is falling (movement of hair and clothing) and how the figure is preparing a breakfall (looking in the direction of fall, arm extended to help distribute weight and chin tucked down to chest). The belt is made of a heavy cotton and doesn't fly around too much.

3 COLOR AND SHADE

Be mindful of the source of light in this drawing when coloring and shading. In the end, the figure should appear three-dimensional. Flat color looks flat while rounded, shaded forms give the illusion of a three-dimensional illustration.

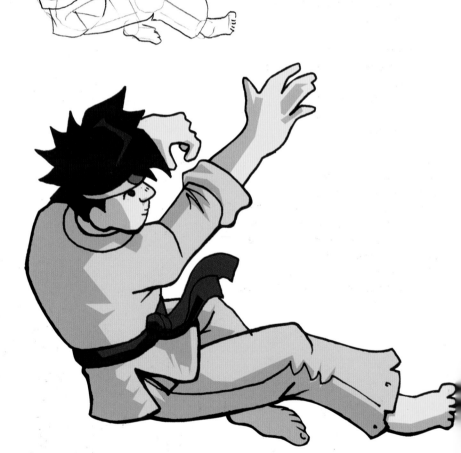

High Circle Throw

This is a sacrifice throw where both people fall during the technique. It's a classic case of falling backwards and propelling the attacker off and away with a combination of momentum and leg strength. The person executing the throw needs to land in a controlled way and send the attacker flying.

Rewind

The moment before the final image reveals how the move was executed. The foot is quickly placed to allow for a strong kick under the pelvis that assists the throw.

The defender's back is curved to allow a roll. The chin is tucked down to avoid neck injury.

1 BLOCK IN THE FORMS

Block in the basic pose using shapes and forms. Try to imagine the direction of movement and show the pose in the most dynamic stage of action.

2 CLEAN UP THE FINAL LINES

Clarify the details, including the placement of the hands and feet. Notice how the fingers create stress marks on the areas where they grasp the clothing. It is also easier to see that the attacker's body weight is supported with the bottom of the defender's right foot as the throw is executed. Complete the illusion of movement with hair direction and the movement of the cuffs.

3 COLOR AND SHADE

Color and shade to give the image depth and solidity. Make each gi and each grappler's skin a different shade to reduce confusion. Try to show a sense of movement in your action drawings. Direction lines or blurring could also indicate more dynamic movement, but don't rely on these tricks too much.

Standing Throw

This is one of many standing throws (tachi-waza), utilizing foot, hip, or in this case, hand techniques. The defender grasps the opponent firmly and leads them to the ground as the body pivots and the leg trips.

The main element of this throw is timing. The move requires that the opponent is caught off balance and then the hands, legs and hips can work to throw even the largest opponent.

Tachi-Waza Variation

This variation is a standing throw where the opponent's momentum is used against them. The defender drops down, twists their body, driving the right forearm into the opponent's right armpit. This forearm lift helps create the leverage required to execute the throw. The left hand has a firm hold on the right elbow. The opponent is thrown over the defender's right shoulder.

1 BLOCK IN THE FORMS
Block in the figures carefully. Notice that the attacker is being pulled to the side with the arms and the twist of the defender's body. The defender's right leg is also used to trip the attacker as the left leg supports the weight required for the throw. The pelvis and shoulders of the defender should angle down toward each other to create an acute angle.

2 CLEAN UP THE FINAL LINES
Clean up all the lines. When you are blocking in the details over the shapes, be aware of the "drawn through" elements and erase confusing lines. Both hands are used to pull the attacker off balance. The opponent is rotated in a circle and is not driven down until the last move of the technique. The defender should always face in the direction that the attacker falls.

3 COLOR AND SHADE
Color and shade the figures to show the force in the technique. Add stress lines on the clothing and clenched fists. The shadow of the attacker on the defender helps illustrate that the defender has dropped below the center of gravity of the opponent. Keep things neat and crisp at this stage.

Sweeping Inner Thigh Throw

This maneuver sweeps the opponent's hips and legs out from under them, propelling them to the ground. It's a combination of the attacker's momentum, the pivot of the hips and a strong pull from the arms in the direction of the fall.

1 BLOCK IN THE FORMS
This is a fairly complex image, but you need to show both characters in grappling martial arts or else it looks kind of strange. Don't be intimidated showing multiple characters. Break the figure down into basic shapes and pose them. If you have friends you can corral into posing that's great, but if you're unable to muster the troops, action figures can do in a pinch.

2 CLEAN UP THE FINAL LINES
Elaborate on the details, particularly the hair and clothing to help show movement and momentum. You can see that the leg of the attacker is moving up because the pant leg cuff is moving the opposite direction of the movement. Remembering details like this can really add dynamic movement to your drawing.

3 COLOR AND SHADE TO FINISH
Finalize the image with color and shading. Don't forget to keep the shadows consistent with the light source. Highlights on the hair add to the three-dimensional appearance of the character and avoid the "flat" look.

UNIFORM AND EQUIPMENT

Judo is a fairly cost-effective sport with few expenses on gear or equipment. A basic high-quality uniform is what's really necessary as the practitioner will be scrambling on the floor and mats and will be grappled and tossed repeatedly.

Belt Rankings

Belt ranking can vary from club to club, country to country. In Europe and Canada rankings advance from white, yellow, orange, green, blue, brown through black. Red with white stripe is set aside for sixth to seventh level black belts and red belts are for senior judoka of eighth to tenth level.

The United States Judo Federation advance adult judoka with white, green, blue and brown belts.

UNIFORM

Judo uniforms are referred to as judogi. The judogi consists of a loose-fitting heavy cotton jacket (uwagi) and baggy pants (zubon). The material needs to be extra thick and reinforced as practitioners of judo are frequently grappled and tossed.

DISCIPLINED ART

Judo is a martial art that requires much discipline and dedication for success.

BELT TRADITIONS

Belt traditions vary, but most beginners wear white belts. In Japan the age of the participant generally determines the belt color. Some judo clubs have only white and black belts. Some use green belts to indicate intermediate students and brown for more advanced students. Individual countries use a variety of belt colors of varying complexity.

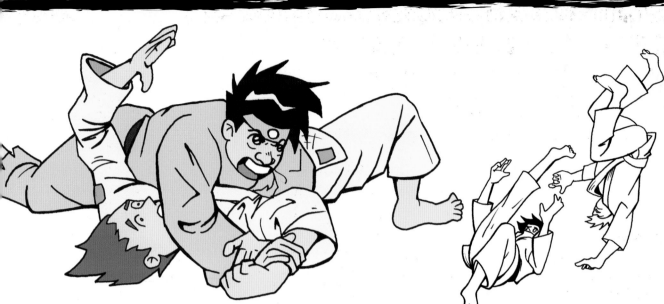

USING PAIN TO IMMOBILIZE

Wrist holds and complex arm holds such as this ude garami can be effective and painful ways to immobilize opponents in judo. Here, the opponent is pinned on the back through a combination of body weight on the torso and a shoulder, plus elbow and wrist lock of the right arm. Pins like this may be effective in tournaments as the opponent has a free arm to strike the mat in an attempt to give up. In a more desperate battle, the arm would somehow also be immobilized with the right knee on the left arm.

DEPICTING ACTION

This throw is the end result of the tomenage circle throw. Try to depict the judo uniform as loose fitting and made from a fairly heavy material. Notice that the gi of the attacker is moving away from the direction of movement.

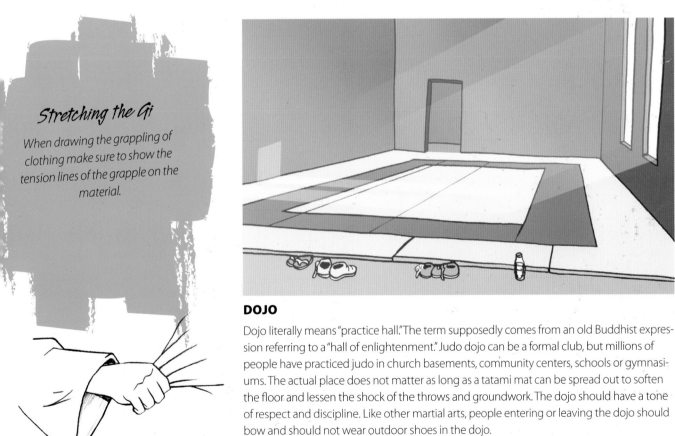

Stretching the Gi

When drawing the grappling of clothing make sure to show the tension lines of the grapple on the material.

DOJO

Dojo literally means "practice hall." The term supposedly comes from an old Buddhist expression referring to a "hall of enlightenment." Judo dojo can be a formal club, but millions of people have practiced judo in church basements, community centers, schools or gymnasiums. The actual place does not matter as long as a tatami mat can be spread out to soften the floor and lessen the shock of the throws and groundwork. The dojo should have a tone of respect and discipline. Like other martial arts, people entering or leaving the dojo should bow and should not wear outdoor shoes in the dojo.

Karate

Karate is loosely translated from Japanese as "empty hand." Karate combines Chinese fighting techniques with an indigenous system developed on Okinawa, a small island located between Japan and China. Because of its strategic location, Okinawa endured wave after wave of conquest and occupation. During an occupation by the Japanese in the fifteenth century, Okinawans were forbidden to own, use or carry weapons. The Okinawans learned their martial art in secret and fashioned common farm implements and tools as weapons.

Karate arrived in Japan in the early twenieth century when Gichin Funakoshi developed a system that had the etiquette and discipline of judo and the style of Okinawan empty hand fighting. This was the origin of the Shotokan faction (ryu) of karate. There are four main ryu and literally hundreds of factions and subfactions of karate in Japan and Okinawa. Each faction has unique characteristics that set them apart from each other.

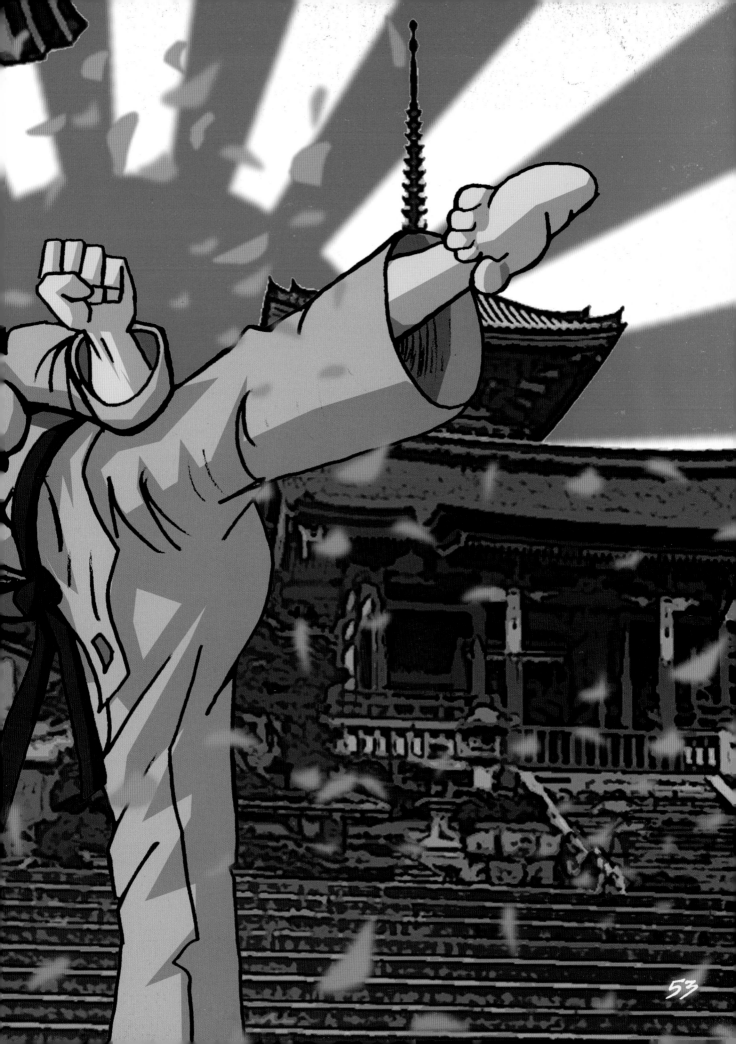

53

STRIKING ART OF THE EMPTY HAND

Karate has a wide range of stances (dachi), each designed to lower and stabilize the center of gravity and set up the martial artists to defend themselves or deliver a powerful attack. Moving from stance to stance is an important skill used in patterns of movements or kata.

Kata

When opponents square off in a karate sparring match, or for a kata, there are often a series of strikes and blocks that are performed. These kata reinforce technique to condition the body for combat.

Back Stance

Half Moon Stance

Horse

Internal Divided Conflict Stance

Rooted Stance

Forward Stance

Cat Stance

Ready Stance

MINIMIZING YOURSELF AS TARGET

Stances provide an opportunity for the martial artist to maintain a solid footing when striking and defending. This avoids tripping and the possibility of being knocked off balance. Stances also minimize the target that they present to the opponent.

STANCES

The forward stance (zenkutsu dachi) is one of the most common stances in kata. In the cat stance (neko dachi), most of the weight is on the bent back leg with the forward leg ready to snap out. The next stance is the "ready" (hachiji dachi) stance.

The back (kokutsu dachi) stance, the half moon (hangetsu dachi) stance and the horse (kiba dachi) stance are important yet less common. Originally developed to take on multiple attackers, the internal divided conflict or saddle stance (naihanchi dachi) is used as a close-fighting technique with surefooted side-to-side cross steps. The rooted stance (sochin dachi) maintains a stable footing and sets up the opportunity to explode into a side snap kick with the rear foot.

A FOCUSED MIND

Karate requires a focused mind and a sense of purpose. Most practitioners sit in sieza position, close their eyes and use controlled breathing to prepare for their training. The back is straight and the shoulders are relaxed.

Movement

Movement in stances is kept low and in wide sweeping steps to maintain balance. Notice how close the combatants are in relation to the other and also how low the stances are.

STRIKES

Basic hand strikes are launched from the chamber position and use the twist of the hips and torso to add power to the punch. The fist is loose until just before impact.

Upper Block

Inside Block

Low Block

BASIC BLOCKS

Some basic blocks include the upper block, which is on an angle above the head. This is intended to deflect the strike away from the head. The low block derives power from a quick exchange along the opposite arm, creating a spring-like snap for the block. The inside block is performed just like drawing a sword from a scabbard.

POINT OF IMPACT

The fist should strike the target with the inside two knuckles of the hand. These knuckles line up with the bones of the arm and provide a stronger punch. The thumb should be tucked below, but not under the fingers.

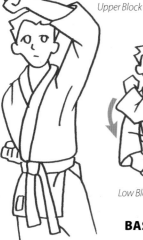

SIDE KICK

The side kick is an outward push of the leg to strike the target. The kicker twists their back leg around and pushes out. This must be precise and done fast.

HI-YA!

The kiai is a short yell that accompanies a strike. It is used to focus energy and distract or intimidate the opponent.

ROUNDHOUSE KICK

A roundhouse kick brings the back leg up and then uses the momentum of the lower leg and foot to snap into the kick. The ball of the foot or the top of the foot is used to strike the opponent.

Knife Hand Strike

This is often referred to as the "karate chop." The strike uses the edge of the hand from the knuckle to the wrist. The fingers are slightly bent, temporarily hardening this area as muscles and tendons tighten up. It is particularly dangerous against soft tissue such as the neck.

Strike Movement

To add to the power of the strike, the right hand is raised to the right ear. The body rotates away from the target slightly. The strike then moves across the body.

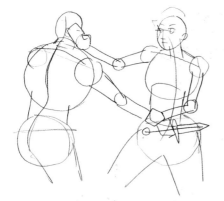
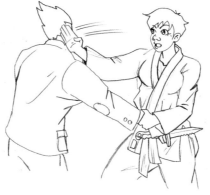
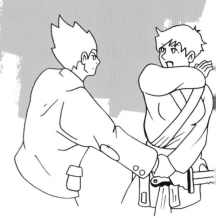

1 BLOCK IN THE SHAPES

Notice that when the strike hits, the body rotates toward the target and the left hand pulls the target towards the striker, upsetting the balance. Usually the left hand would tuck up into chamber position, but in this case, the left hand has grabbed a weapon hand.

2 ADD DETAILS

As you add details, be aware of folds and creases on clothing to help express tension and movement instead of having to draw action lines for everything. Action lines add to the appearance of force in the strike. Overuse of action lines can cheapen their impact, but it is traditional in manga and comics to use these lines to indicate movement.

3 COLOR AND SHADE

Color the image to reinforce the three-dimensional nature of the forms and separate the two figures from each other.

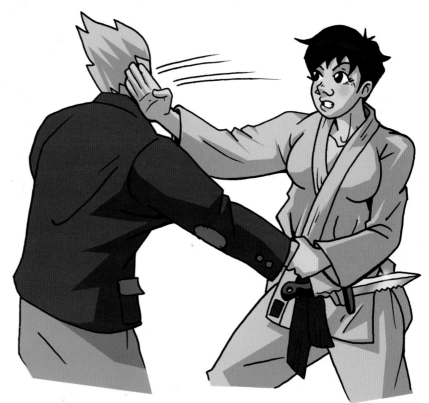

Elbow Strike

The elbow can be a seriously effective close-combat weapon. It's fast and delivers a solid strike that sets up the attacker for a punishing backhand strike. Elbow strikes are most effective in areas such as the solar plexus, the face and neck, the stomach or the back.

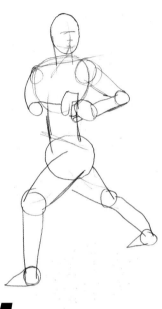
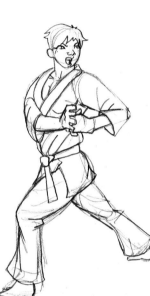
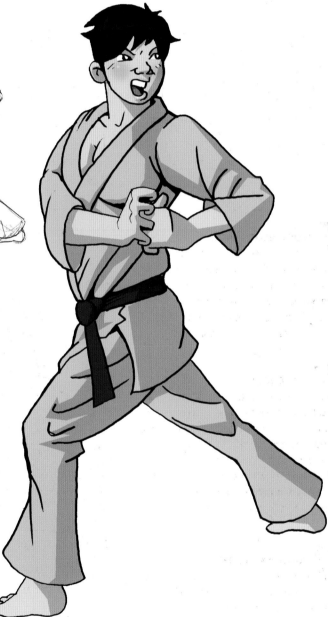

1 SKETCH THE FIGURE

Sketch the figure in a back stance with a strongly rooted center of gravity. Depict the point when the strike should hit the target. Notice how the opposite hand supports the striking arm. Twisting the body adds to the power of the strike.

2 INDICATE THE BODY AND ADD DETAILS

Indicate the twist of the body as the strike hits. The belt does not fly around too much because it is made of such a heavy material.

3 COLOR AND SHADE

Use color and shading to express more folds and creases in the clothing. The figure would probably turn and face the opponent after this strike by pulling the front (left) leg back in a C-shaped step. Movement in karate avoids lifting the leg or changing the height of the fighter as that may lead to potential unbalance.

Side Kick

This very high side kick requires some serious training and warm up. Remember that when you are drawing a kick in karate, there is a definite snap of the leg with the strike. The foot should be twisted so that the knife-edge (outside edge) of the foot or the heel hits the target. A kick this high is often impractical as it uses a lot of energy and can make for an easy target.

1 **SKETCH THE FIGURE**
Notice how the figure leans far back to allow the stretch of the leg to increase the height of the kick. The arms should be kept up to defend from any punches or kicks that might slip through this massive attack.

2 **ADD DETAILS**
The stretch of the pants shows why it's a good idea to use loose-fitting or stretchable clothing in the martial arts. Other pants might just rip with a wide kick like this. The ripple of the pants on the kicking leg shows the power of the kick.

3 **COLOR AND SHADE**
This kind of kick is aimed at the head or neck of the target. It is a devastating strike and is life-threateningly dangerous. Notice how the light direction affects the color and shade of the figure.

Flying Side Kick

This is not a very practical kick in reality, but it's fun to look at and great to draw. It's not something very common to karate which tends to rely on strikes that have focused, penetrating power, not necessarily "knock down" power. In martial arts manga, sometimes the practical is set aside for the flamboyant.

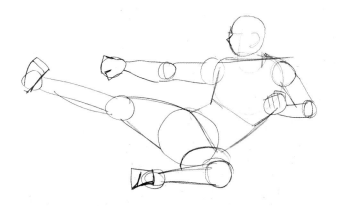

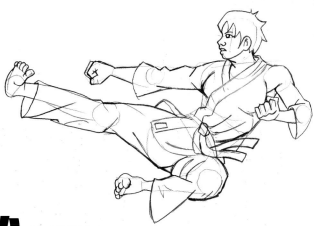

1 SKETCH FIGURE

This can be a complex pose to draw. The key features to note are the foreshortening of the tucked-under leg. The twist of the foot ensures the knife-edge of the foot strikes and not the toes.

2 ADD DETAILS

Note how the arm goes back into the chamber and the right arm is extended in a strike. This is a very impractical move, but the extended arm could help defend the body or trap an opponent. The dynamism of the movement is reflected in the effect of the wind on the clothing and the hair.

3 COLOR AND SHADE

Having the figure relating to a background or another character would put the pose in context. We would get a better sense of how high off the ground the kicker is and what connection they have with the target. Remember to add the details of the folds and creases of clothing at this stage, but don't overdo it. Too much detail can be distracting and take away from the overall image.

UNIFORM AND EQUIPMENT

Many of the weapons found in karate were originally used as farming equipment. The invading Chinese and Japanese might have taken away the obvious weapons of the Okinawan warrior, but they didn't take away the ingenuity or fighting.

Okinawan women studied dances that had hidden martial arts techniques and passed these on to the next generations to keep the knowledge alive during times of occupation when practicing the martial arts was forbidden.

Belts Should "Grow" Darker

Belt ranking in karate was adapted from the practice in judo by Gichin Funakoshi. Belt advancement, rank and colors vary from country to country and dojo to dojo. One dubious story states that the old karate masters never washed their belts that grew progressively darker as they trained. Someone with a dark belt would have trained for years and years to accumulate all that dirt. The traditional Okinawan belt ranking system is white, yellow, green, brown, black, red with a white stripe, and red.

THE KARATE GI

The karate gi is a light- medium- or heavy-weight cotton suit. The use of the gi as a standard uniform was adopted in the nineteenth century after Gichin Funakoshi (the founder of Shotokan karate) met Jigoro Kano (the founder of judo). The gi is traditionally white, but colors and even patterns may vary depending on the club or sensei (teacher).

SPARRING GEAR

Protective gear for sparring is really suggested for both combatants. It's also important not to wear any jewelry and make sure fingernails and toenails are clipped low. Many a martial artist has painfully lost a fingernail or toenail from a kick that got caught in someone's gi (at least I have).

OTHER PROTECTION

Protection includes a mouth guard and helmet as well as foot and hand guards. Notice the toes sticking out from under the foot guards. People studying karate need to protect themselves from injury.

SAI

The sai is a metal baton with two unsharpened projections (tsuba) and it is an excellent weapon for defense from swords and spears. It can be used to trap weapons or as a weapon in it's own right. The handle can be used to strike the neck or solar plexus. The metal baton can be used as a striking weapon or it can be used to hook and trap weapons much like a kama (see below). It has been suggested that the sai originally was some form of farm implement or a wagon wheel pin.

TONFA

Originally used to help grind flour, the tonfa has been adopted by law enforcement organizations around the world as a police baton. It is a wooden shaft that fits along the forearm, just past the elbow. It is an excellent defensive weapon, protecting the hand and elbow from strikes. The weapon is often twirled around for striking. The handle can be used as a hook as well and is usually used in pairs.

KAMA

The kama is a traditional sickle used for harvesting crops. In combat with an opponent using swords, staffs or spears, it can trap and block long weapons and attack with the opposite hand. Practice kama are made entirely of wood.

NUNCHUKA

The nunchuka is one of the most famous and difficult to use weapons in martial arts. It is used as a blocking weapon, but is a fast striking weapon of incredible power. The chain can be used to trap weapons. A martial artist swinging a pair of nunchuka can clear space pretty quickly. It has been suggested that the nunchuks were originally used as a flail to thresh rice.

BO

The bo or wooden staff is a convenient weapon of choice because it is so common to find. A broom handle will do in a pinch. The bo is held with two hands, the rear hand propels the bo at the target and the front hand guides it. The bo is one of the oldest martial arts weapons. It is a favorite weapon of monks and travelers.

Kickboxing

Western kickboxing originated in the early 1970s when there was a rabid interest in martial arts and karate practitioners were frustrated with the scoring systems used in tournaments. Links were quickly made to Muay Thai, a fast and brutal style from Thailand and modern kickboxing was born. Muay Thai techniques involve elbow and knee strikes as well as punches and kicks. Western kickboxing does not allow elbow or knees strikes. In both styles participants cannot grab or throw their opponent. Muay Thai is the national sport in Thailand where it has been practiced for hundred of years. Modern Muay Thai is full of character, pageantry, customs and rituals. Western kickboxing has survived as a martial art, but many local laws prohibit the practice of widespread professional kickboxing. We'll look at both approaches in this chapter, with a stronger emphasis on traditional Muay Thai.

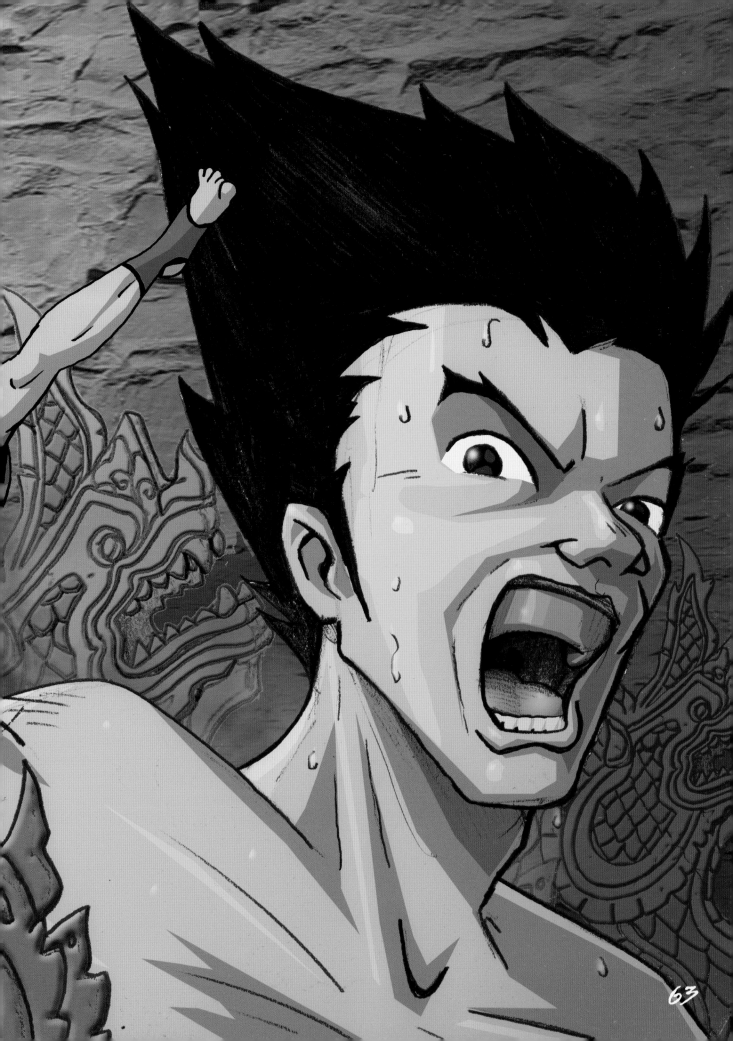

THE ART OF THE EIGHT LIMBS

Kickboxing is an interesting mix of the traditional martial art Muay Thai (literally, thai boxing) and the competitive boxing match. Action usually resembles boxing until the combatants start kicking, then the devastating power of the kick is revealed. A single kick to the temple can end a fight with a knockout and threaten the life of the target.

Kickboxing For Fun and Fitness

Kickboxing clubs have sprung up recently cashing in on the fitness craze of the past two decades. Most people study kickboxing in gyms and clubs to tone muscle and burn calories with no desire to enter a ring and duke it out. An hour of kickboxing can burn between 400 to 800 calories per hour and is a good stress reliever. There are no formal kata or forms to learn. It's all about technique, balance, flexibility, coordination and stamina. It's also a lot of fun.

READY POSITION

The basic fighting stance moves the favored leg forward from the ready stance, providing a flexible platform for defensive and offensive actions. The weight is on the back leg. The front leg is ready to snap up in defense if needed. Elbows are tucked along the body to protect the ribs. Feet are just beyond shoulder width with both knees slightly bent. The fists should be far enough from the body to strike the opponent quickly, but close enough to block attacks. The eyes should remain on the opponent.

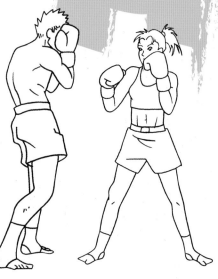

TAKING DAMAGE

Kickboxers are trained not only to dish out damage, but also to take it. When preparing to be hit, fighters raise the arms and gloves in defense. They also plant their feet on the ground so they are less likely to be knocked down.

GLOVE PLACEMENT

Avoid placing the gloves too high or too far from the body. This obscures vision and opens the torso to attack. As the fighters grow tired during a match, this becomes harder and harder to remember for the injured. Simple mistakes can cost the match. The lead fist is placed two fists out from the body and the rear fist rests on the chest or chin.

Movement

Kickboxers bob and weave just like regular boxers. Footwork is loose and springy, but not too bouncy. It is important to keep moving in the ring so you are not a sitting duck. Sudden, explosive strikes can come at any time so maintaining balance is important.

BLOCKING WITH THE LEG

Raising the leg can stop an incoming kick and set up the kickboxer for a devastating counterstrike. Notice how the elbows and fists stay up to protect the torso and head.

SIDE KICK

This basic kick starts by raising the knee as high to the chest as possible. The toes point to the floor and the back foot should stay flat on the floor to maintain balance. It's a good idea to keep the fists up to defend the torso and face. The foot should snap out and retract immediately so the leg is not trapped in a clinch. The leg must retract fully in order for tournament kicks to count.

ROUNDHOUSE

A roundhouse kick snaps in from the side of the kickboxer. It is a good strike to hit the ribs or head. Part of the power of the kick comes from the snap of the lower leg as the leg is straightened. Some kickboxers jump to deliver this kick, adding momentum and height to the strike.

PUNCHES

Standard boxing punches can also flatten an opponent and the power of the punch cannot be underestimated. The hook, uppercut and jab are used as they are in boxing (see page 22). Kickboxers soon realize that relying on kicks only can quickly wear down the stamina of the fighter.

HIGH SIDE KICK

This high side kick shows the importance of keeping defenses up during an attack. The ribs and face are well defended here. This impressive attack is designed to hit the jaw or side of the head. Make sure the back heel is firmly planted on the ground.

The Power Source

All strikes use the whole body, drawing power from hip rotation for kicks, punches and blocks. This can slow down the movement, but adds tremendous power.

Front Kick

The most basic of all kicks, the front kick is essentially a push out with the leg. The toes should be pulled back and the point of impact is the ball of the foot. The grounded foot should twist out to maintain balance and generate torque. This example shows a fighter leaning back on the ropes and attempting to push away an attacker.

Arms Can Denote Fatigue

This view of the front kick illustrates the tendancy to drop the arm of the kicking leg to counterbalance the shift of weight and to get the elbow out of the way. The defenses should be up, but this fighter is getting tired and desperate.

1 BLOCK IN THE BASIC FORMS
Block in the legs and arms as three-dimensional, not flat, shapes. Notice how the arch of the back is indicated by an initial line dropped down from the head to the pelvis. This line of action helps counterbalance the fighter.

2 ADD DETAILS
Reinforce the motion. The fabric of the shorts moveS opposite the kick. The defenses are kept up in this drawing. Draw the gloves tilted open as the elbows move out to allow the kick to rise above the hips.

3 ADD COLOR
Color the image to reveal the shading and form of the figure. Details in manga should be included when it is absolutely necessary in developing the story, not just to fill in space. The blue teeth are actually a mouth guard.

Axe Kick

This powerful kick is designed to break the defenses and disorient the opponent as it rises. It then crashes down on the head or shoulders to knock down the target. Ouch, that's gotta hurt!

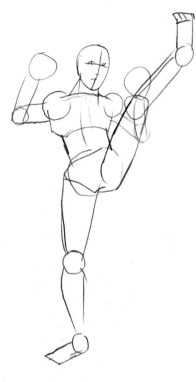

1 **KEEP IT SIMPLE**
Block in the shapes and suggest the simple anatomical details: the back foot twists outward and the gloves are up in defensive position.

2 **ADD DETAILS**
Add details by blocking in anatomy and clothing information. As the foot rises, the toes need to be pulled back to avoid injury as they break through the opponent's defenses.

3 **COLOR AND SHADE**
At this stage, use shading to create details of anatomy and clothing creases. The elbows are raised to make room for the kick, but they should tuck beside the body once the kick is finished. As it is, the arms are providing some defense, but not nearly enough if the axe kick misses.

Spinning Back Kick

Also known as a donkey kick, this kick connects with the heel and is accompanied by a spin of the body. The speed of delivery and focused power of the spin makes this a very potent kick.

Right Back at You

This alternate view of the spin kick shows the moment of impact. This is a very high kick and must be executed quickly as it leaves the back of the fighter undefended for a moment. The kick is often a surprise as the telltale leg lifting is hidden from view until it strikes.

1 KEEP IT SIMPLE

Pay attention to the biomechanics of the figure as it rotates. The open arms increase the power of the spin by using the weight of the arms to add to the kick's impact.

2 ADD DETAILS

Block in the details of the character at this stage. The elements of the drawing—hair, clothing and muscle detail—should all indicate a twist or torque in the figure to indicate movement. The heel is the point of impact with the rest of the leg and foot used to push back on the target. The momentum of the spin adds to the attack. Note also that the weight is on the balls of the attacker's left foot. This allows the kicker to pivot on the ground, but it is difficult to maintain balance. Notice that as in most martial arts the point where the weight is supported usually lines up with the head.

3 COLOR AND SHADE

After the anatomy and costume details have been cleaned up, it's time to add color and shading. The shading should help convince the viewet that the subject appears three dimensional so make sure you try to depict the forms of the figure as you add shading. To emphasize movement you may even consider blurring the leg or figure. Relying on special effects such as blurring can detract from your artwork and make it difficult to understand what the character is doing. Use it wisely.

Flying Spinning Back Kick

You know what's even scarier than a spinning back kick? A flying spinning back kick! Flying kicks are saved as finishing moves as they are not as reliable as standard kicks and have a lot of power invested in them that could tire out the fighter quickly. The fighter is also fairly defenseless for a few moments as they land. This is a full-out offensive strike that takes a lot of skill and guts to pull off.

1 KEEP IT SIMPLE

Draw the line down the back as the line of action to quickly block in the pose. From it, develop other forms to establish the anatomy and body position. The back leg has just left the ground and the toes are pointing down. Notice the foreshortening in the right forearm moving away from the viewer and being obscured by the upper arm.

2 ADD DETAILS

It's detail time! Look how the short's leg is really flying from the force of the spin kick. Emphasize the twisted back to reveal details of the shoulder blades, spine and ribs. Make sure your initial lines are lightly drawn so they can be easily erased.

3 COLOR AND SHADE

Suggest areas of light and dark. Anatomical and costume details can be added by shading and defining muscles and clothing folds. This sort of kick requires some sort of running start. A jump kick usually targets the body while these flying kicks target the head.

UNIFORMS AND EQUIPMENT

Kickboxing in the West has become a popular fitness trend and self-defense style. There is less commitment and expense compared to other martial arts. Kickboxing has become popular with women with some clubs boasting 75 percent or greater female memberships. Professional kickboxing is televised and has a devoted following. With the rise of the Internet, more people in the West are discovering Muay Thai and there seems to be an interest in the traditions and history of this martial art.

UNIFORM

Kickboxing has a similar look and feel to boxing with participants wearing loose shorts and protective gloves.

Some schools offer belt ranking similar to other martial arts like full-contact karate and judo. Mostly, kickboxing is a full-contact sport like boxing where you are only as good as your last match. Most people take kickboxing for self-defense and fitness anyway and are not as concerned with belt ranking.

GLOVES

The gloves are similar to those used in boxing and are often wrapped on the outside to make sure they don't move around.

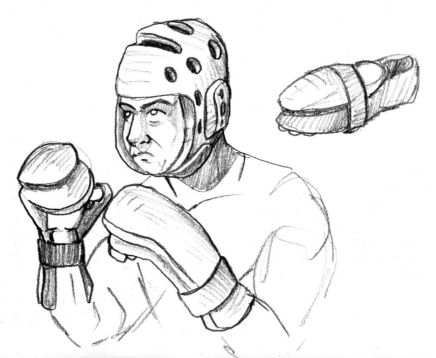

HEADGEAR

Professional kickboxers don't wear protective gear and injuries can be quite severe. Head injuries are the most damaging, usually from repetitive head trauma. One Australian study of injuries discovered that out of a thousand matches, head, neck and face injuries occurred 52.5 percent of the time. Leg injuries occured 39.8 percent of the time. Cuts and bruises made up only 64 percent of the injuries.

RAM MUAY RITUALS

Traditional Muay Thai participants perform a complex ritual dance before a fight. The ram muay literally translates to "dance boxing." It shows respect to the opponent, teachers, parents, ancestors and trainers of the boxers, similar to the bow of most martial artists before a contest but more complex. Hands are put together as if the fighter is praying. It is also used as a warm up and stretch before the fight.

These rituals involve bowing three times in the direction of the fighter's home to show respect for where they came from. The ritual ends with the boxer stomping three times in the direction of the opponent, symbolically crushing them. Ram muay is traditional for Muay Thai, but not in Western kickboxing, where a short bow and glove tap suffices.

MONGKON

Traditionally fighters wear a head ring called a mongkon and one or more armbands (praciat) that were blessed by Buddhist monks for good luck.

HEAVY BAGS

Using heavy bags is an important experience when practicing kickboxing to get a sense of the power required for body blows and to condition the body for striking a target.

RINGS

Kickboxing matches usually happen in traditional boxing rings. Like a regular boxing ring, there are ropes attached to turnbuckles. Matches are broken down into rounds and end in a knockout, a technical knockout, decision, disqualification, or draw.

Kung Fu

Kung fu is roughly translated as "sustained effort or skill." It is entirely inaccurate to lump together hundreds of diverse styles of Chinese martial arts and call them kung fu. There are definite similarities between all these styles, but each has an individual history, tradition and discipline that is remarkably unique. Most Chinese martial arts are derived from the five animal styles that originated almost fifteen hundred years ago from the Shaolin temple in China's Henan Province. There has been a concerted effort by the Chinese government to combine these martial arts under the term Wushu (literally, martial arts) and promote it as a sport. But recently there has been a return to respecting the traditions of individual Chinese martial arts and treating Wushu as a separate sport.

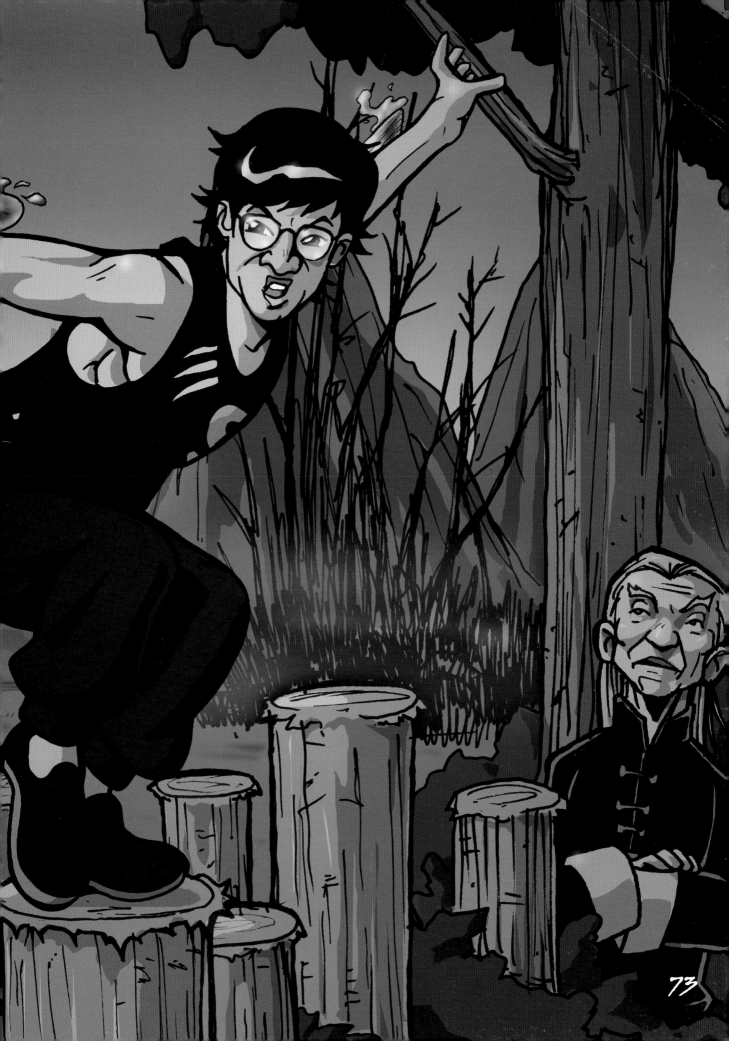

CROUCHING TIGERS, HIDDEN DRAGONS

The inspiration for traditional Shaolin kung fu is reputed to come from Buddhist monks mimicking the movements of animals. Kung fu is a relatively circular, open handed style that uses natural bio-mechanical body motion and speed to unleash devastating power.

Hard Work

Kung fu (gung fu) means "hard work" or refined skill. Combatants bow to each other respectively and raise their right fist to an open left hand.

KUNG FU STANCES

Stances are important for maintaining balance and they reinforce energy or chi. Maintain consistency in stances. There are hundreds of styles and substyles of kung fu. Some styles favor some stances over others. Familiarize yourself with their characteristics.

The power of the crane stance is in the momentum created from swooping down to strike. The horse stance is a solid stance, designed for maintaining ground and balance. The very low cat stance allows the front leg to snap out.

The eagle claw stance is based on a very complex and acrobatic northern form of kung fu. The sit the belly stance is a very low version of the praying mantis. It is a solid, deeply rooted stance. The knee should not be in contact with the ground unless the strike or defense demands it.

The falling stance is an excellent defensive stance, useful for evading attacks. The prostrate stance is useful as a defensive stance that allows for a quick counterattack. The unicorn step (cross) stance allows for the figure to react or "give" to a blocked strike and the twisted horse stance creates a strong twisting force to enhance power. The heel or seven star stance is also seen in tai chi. It is a useful move for scooting forward quickly without lowering defenses or shifting body weight.

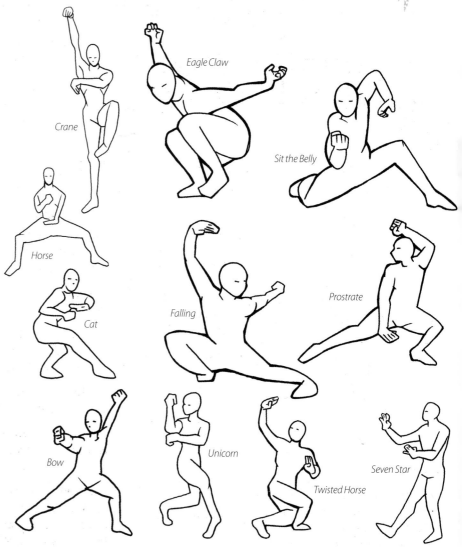

Crane

Eagle Claw

Sit the Belly

Horse

Cat

Falling

Prostrate

Bow

Unicorn

Twisted Horse

Seven Star

Movement

Kung fu movements are fluid and circular. They should erupt from the attacker with speed and power. Don't forget to draw the characters keeping their arms up to defend from a possible counterattack. Maintain supple hips and legs to ensure kicks have a full range of motion. Depict the flexibility of the martial artist by showing them drop into wide, low stances and execute impressively high kicks.

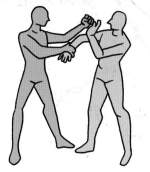

STICKY HANDS

Sticky hands is a paired practice from wing chun, one of the most popular forms of kung fu. Wing chun martial artists without a practice partner use a wooden dummy (mook yan jong). The arm movements are circular, using the natural arcs of the human figure.

SNAKE STYLE

Snake style is an undulating, weaving style that simulates the strike of a snake. It's precise and fast, targeting the throat, eyes and temples as well as damaging strikes to nerves and pressure points.

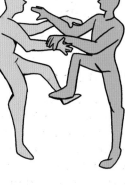

STICKY LEGS

Sticky legs is similar to sticky hands, but focuses on kicks and footwork. Low kicks like this are designed to break the opponent out of their stance and upset their center of gravity.

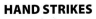

HAND STRIKES

These striking techniques are representative of the traditional five animal styles found in Shaolin kung fu.

TIGER: low, powerful stances and hand forms used for grappling and clawing.

DRAGON: straight fingers for striking vital points on the body. In some traditions, the index finger is raised and used for thrusting.

SNAKE: fast and flowing strikes relying on swiftness, timing and accuracy.

CRANE: like the beak of a crane, the strikes are powerful and accurate with focused impact.

PANTHER: like a paw, relying on powerfully conditioned knuckles. This form relies on flat and piecing strikes using the flat edge of the knuckles for various effects.

Tiger

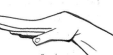

Dragon

Snake

Crane

Panther

KICKING

Kicking in kung fu is a fast and devastating attack. It is often associated with "northern styles" of kung fu such as Shaolin "long fist." These techniques were designed to keep great distance between the combatants.

Tiger Claw Strike

Shaolin tiger movements simulate the tearing motion of tiger claws. It is a rigid, open hand technique that uses downward arcing swings as well as palm and forearm blocks in a downward sweeping motion. The wrist twists the fist as the blow strikes and produces amazing power. As the name suggests, this form was based on the characteristic movements and attacks of the tiger.

1 **BLOCK IN THE FIGURE**
Block in the basic forms paying close attention to the stance and arm placement, making sure the figure is posed properly. Keep things simple at the start. Don't be afraid to "draw through" to help keep the elements of the figure in proper proportion.

2 **ADD DETAILS**
Add details such as the clothing, hair and face to give the character personality and individuality. Confusing structure lines can be drawn over or erased. Even though the facial expression is exaggerated, the image doesn't seem overly cartoony because of the accuracy of the figure's pose.

3 **COLOR AND SHADE**
Add color and shade to breathe life into the final drawing. Notice that even though the yin-yang symbol on the shirt is a simple black and white image, the white on the shirt has been knocked down to a gray in order to reinforce the light source and develop the figure as a three-dimensional form.

Monkey Style Strike

Monkey style is steeped in history and legend. The movements imitate those of monkeys or apes. It is a flamboyant and humorous style, using colorful acrobatics and unpredictable and random movements to confuse and surprise opponents. It is a style that uses rolls and squats as well as long reaches, grabs and arm swings.

1 BLOCK IN THE FIGURE

Block in the pose using construction lines. Remember that the angle of the hip and the angle of the shoulders will complement each other and point in opposite directions. "Draw through" the forms to get a better sense of where anatomy is located. Imagine that the tubes, circles and shapes used to construct the figure are made of glass or clear plastic.

2 ADD DETAILS

Block in the details carefully, considering the flow of material on this classic Mandarin-style outfit and the monkeylike hands, ready to block and grasp any attacks. Be careful with the proportions so that the head, hands and feet are in proper proportion with each other and the rest of the figure.

3 COLOR AND SHADE

Finish the image and create depth of form. Keep the light source consistent as you shade your image. Be aware of what parts of the figure are shadowed because of the three-dimensional form of the figure and what parts are shaded using external shadow sources. The final image uses highlights and gray to indicate that this is a black uniform. The thin lines act as a convenient way to differentiate distinct elements from the basic body shape.

White Crane Style Strike

Practitioners of this style keep out of range of their opponents, dodging and blocking and then, at the right moment, counterattacking with brutal and tenacious energy. The White Crane style then continues a relentless attack, from which there seems no escape, until the enemy is defeated. Stances and movements mimic the motions of actual white cranes using focused strikes with the fingers in a beaklike shape.

The Story of White Crane Style

A Tibetan monk was disturbed from his meditation by an ape attempting to steal eggs out of a crane's nest. The monk observed the crane and ape and was impressed with the crane's ability to ferociously defend its nest and launch a fearsome attack of its own on the ape. Hence, the movements of white crane style are grand and all encompassing, swinging the arms like wings and twisting the body for maximum power.

1 BLOCK IN THE SHAPES
Block in the basic shapes of the crane stance. Be very aware of the three dimensional shapes of the body parts. Notice how parts of the body overlap each other and therefore appear to be closer. The left thigh is also foreshortened to appear to come forward in space. The right arm is partially covered by the shoulder and head but also uses foreshortening to appear to move back in space. Attention to space and forms makes the figure more realistic and convincing.

2 ADD DETAILS
Carefully add details over the initial drawing to define elements such as clothing, hair and accessories. Make stylistic elements, such as the hand forms, easy to identify. Make sure the initial blocking-in lines are light enough to erase easily after this stage.

3 COLOR AND SHADE
Make sure the light source is consistent in all your shading. Pick a light source and stick to it in the shading as well as highlighting. First and foremost, create a convincing pose, focusing on the defensive strength of crane style. Attacks are evaded or blocked and finally a flurry of precise strikes are unleashed upon the opponent.

Dragon Style Strike

Dragon style uses the coiling of the mythic serpentine Chinese dragon. The martial artist uses loose, circular hip movements and does not have many kicks or jumps, focusing on palm strikes and clawing techniques. Dragon style movement is a zigzag motion, designed to emulate the slithering motions of the dragon.

1 SKETCH THE FIGURE
Start with the basics. Drop the figure down into a low bow stance as the figure zigs to the right. This position will set up an attack, allowing the figure to zag into a new strike. The arms are up to protect the torso and head. Keep the figure strong and confident, ready to strike.

2 ADD DETAILS
Dragon style is all about zigzagging and avoiding attacks, and looking for an opportunity to strike vital points with powerful thrusts of the fingers. The fingers are curved so that when they strike the target, they can spring with the impact and will not break easily. Slight indications of movement on the figure include the stray strand of hair and the flowing pant cuffs that indicate the direction and force of the move.

3 COLOR AND SHADE
Clean up the construction lines and focus on coloring and shading. The black uniform has a blue-gray highlight that helps define the basic forms of the figure and convince the viewer that the outfit is indeed black. The highlights avoid the danger of having the arm disappear into the mass of the body.

UNIFORMS AND WEAPONS

The Shaolin temple in Henan Province was the origin of organized training of unarmed combat in China since the sixth century AD. What has become known as kung fu today was introduced by Indian monks and combined with existing fighting skills. The temple trained powerful warriors of great physical and mental ability. The instructor is known as a sifu and the hall where kung fu is taught is typically called a kwoon.

WUSHU UNIFORMS

These are generally flashier and made from luxurious materials such as shimmering silk. The clothes are meant to flow and accentuate the acrobatic movements of the wushu artist. Wushu officially adopted a belt ranking system in 1998 that recognized nine duan (dan) levels.

Advanced Kung Fu

Belt or sash ranking is not a traditional practice in kung fu and what exists is as varied as the number of individual styles and dojos. Most styles of kung fu use no belt ranking system at all and base advancement upon the time spent and the overall passion of study as well as the individual skill of the martial artist.

MANDARIN JACKET

The classic mandarin-collared jacket is buttoned up with frog buttons made of string loops and knots. The jacket has white rollback cuffs and slits along the sides to allow greater freedom of movement. The pants are loose and allow for a wide range of flexibility. Simple slipperlike shoes with non-slip soles protect the feet.

SOUTHERN STYLE

The sleeveless and collarless kung fu uniform is more common in southern kung fu styles. In some cases the knotted string frog buttons are white or red.

MONK ROBES

The traditional robes of the Buddhist monk were the original garments of the kung fu practitioner. The orange robes signify a vow of chastity and monastic simplicity and leaving behind the comforts of the outside world. Other colors may include yellow, blue and grey. The robes are also cultural shorthand relating to the tradition and ancient legacy of kung fu. Notice how the sleeves and pant cuffs are wrapped with leg ties (bang tui) so that they do not interfere with the actions of the martial artist.

THE QUARTER STAFF

The quarter staff (gun) is a long (five to six foot [two meter]) stick, thinned on one end so it weighs less and moves faster. It is an effective weapon for both striking and blocking and is considered an extension of the fighter. Similar sticks were used to push boats away from the dock. The ease of finding a staff "at hand" makes this a very handy weapon.

BUTTERFLY SWORDS

Butterfly swords (hudie shuang dao) are wide blades roughly the size of the forearm. Often used in pairs, they were traditionally hidden in sleeves or in boots. The hand guards can be used to help disarm weapons and as a punching weapon in and of themselves.

HOOK SWORDS

Hook swords (heaven and sun moon swords) are usually used in pairs, using the hooks to trap and disarm the weapons of attackers. This is traditionally a northern weapon and is considered a very difficult weapon to master.

THE STAFF

The staff is used with powerful effect in monkey style kung fu. It is made of strong and flexible "wax wood" and is preferably the same height as the user. The staff is referred to as the "grandfather of all weapons."

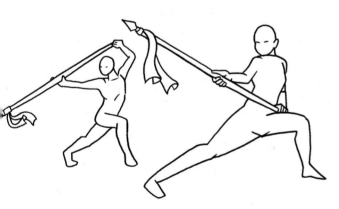

FIGHTING FANS

These are rather elegant, but impractical weapon, useful for defense and concealment, but not as powerful as other weapons. It's a northern, Shaolin weapon.

THE SPEAR

The spear (qiang) was a common weapon in the past because it's easy to produce and use. Chinese spears have a leaf-like blade and traditionally have a red ribbon or horse-hair tassel below the blade which makes it more difficult to predict its movement and also works to divert blood from the handle. The qiang ranges from seven to thirteen feet (three to four meters) and is made of flexible, but strong "wax wood." The qiang is known as the "king of weapons."

BROADSWORD

The sabre (dao) or broadsword is a wide-bladed weapon used to slice or chop. It is known as the "general of all weapons."

Ninjitsu

The chronicles of ninjitsu are more a study of legend than history. The earliest ninja may have existed in the seventh century. They developed their arts in secret in the remote mountains of Japan hiding from the empire's samurai warriors. The modern concept of ninja originated sometime in fourteenth century feudal Japan. The island nation was fragmented into many small kingdoms or principalities and clans of ninja were used as spies and assassins to perform tasks that the honorable samurai would not or could not do.

83

THE ART OF DECEPTION

Ninja have had a powerful impact on popular culture all over the world and have been the subject of many successful manga comics, anime and live action movies.

Mystical Secrets

The weaponless martial art of the ninja is taijutsu (body skill). It is a grappling art that focuses on evasion and falling, kicks, punches, throws and locks. Ninjitsu adds the expertise of deception and terror. Stealth, concealment, spying, disguise and chemistry are the ninja's assets. They are also known for their remarkable tools, weapons and reputed mystic abilities.

ATTACK STANCE

The ninja attack stance is a wide stance. The front leg is bent and supports the bulk of the body's weight. When defending, the body twists toward the direction of the rear foot, the back leg supports the majority of body weight and allows for retaliatory strikes or further defensive maneuvers.

CROSS STEPPING

Cross stepping is a sideways movement where the leg crosses over the other and the feet carefully position themselves back into a solid stance. The arms are crossed across the chest to center the weight and avoid knocking things over. The ninja is able to move forward, backwards and sideways while keeping an eye open in the opposite direction of movement.

STEALTH WALK

This is an unusual way to walk, but it's effective for avoiding traps, tripwires and clearing the path. This is also a very quiet way to get around. With this method of walking, objects obscured by darkness can be avoided.

ENDURANCE, STRENGTH AND FLEXIBILITY

These are the ninja's physical abilities. This low stance provides a smaller target and allows the ninja to remain hidden. The concept of triangle, circle and square is used in all actions, as in aikido. Defensive maneuvers are triangular. Attack techniques are circular. Solid stances are indicative of the square.

Movement

The ninja had to have a powerful set of core muscles to pull themselves up on rooftops quickly and possess the agility to perform acrobatic stunts in order to escape or launch a surprise attack.

STEALTHY LOOKOUT

The ninja crouches to maintain a small profile and uses a crossing side step to keep an eye out behind. Were they followed? Also, the ninja is using a concealed sword technique to reduce his weapon's reflection and glare.

ALL-TERRAIN NINJAS

Ninja must learn to cross all kinds of terrain stealthily. Crawling this close to the ground requires practice and dedication. Three limbs should be used to support the body's weight at all times during movement for stability and an even spread of mass.

LEGENDARY WALL CLIMBERS

Ninja scale impossible heights with limited outside support. "Ninja claws" on hands and feet were used to get a better grip. The ninja hugs close to the wall to avoid detection and limit the tendency to fall backwards. The limbs are outstretched and rarely tightly bent to avoid wearing them out too soon.

KUJI-KIRI

The legendary kuji-kiri finger-knitting techniques are used to focus attention and energy. These secret hand positions were passed on through ninja families to help draw on inner forces of willpower and resolve in order to overcome adversity or maintain calm. Fictional ninja use these techniques to control elemental or mystic forces.

RIN: strength of mind and body, an inner strength designed to get the job done.

KYO: direction of energy within the body used for healing and calming.

TOH: harmony or an awareness of one's place in the universe.

SHA: healing of the self and of others.

KAI: premonition of danger.

JIN: knowing the thoughts of others.

RETSU: mastery of time and space.

ZAI: control of the elements of the natural world, useful in appearing to disappear into the background.

ZEN: enlightenment, a deep understanding of the self.

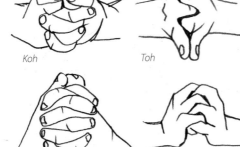
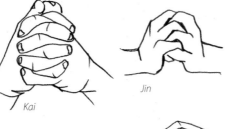
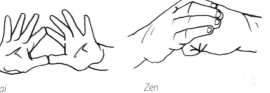

Rin

Koh

Toh

Sha

Kai

Jin

Retsu

Zai

Zen

Defensive Posture

The stance is low and the weight is shifted to anchor the defender to the ground and avoid being knocked over. The sword is kept at eye level, almost disappearing from the point of view of the attacker. It is a subtle, hidden-weapon technique. The body weight will shift forward when the character strikes, using the weight of the character and the forward momentum to launch a devastating attack.

1 DRAW THE STRUCTURE
Focus on the solid posture and structure of the figure. Make sure the legs and arms are considered three-dimensional cylinders. Don't be afraid to "draw through" the figure so that every part of the body is considered and not "fudged." Notice that the leg closest to the viewer appears lower on the page, increasing the illusion of depth.

2 BLOCK IN THE DETAILS
Define the form of the figure. The wrappings around the wrist and shins reinforce the three-dimensional structure. Indicate areas of black clothing by leaving a white highlight outline. While not particularly realistic, it simplifies the problem and allows you to define the structure without turning the character into an amorphous blob.

3 COLOR AND SHADE
Color and shade using a consistent light source. Each element of the figure is a three-dimensional form and should be shaded as such. Not shading flattens the drawing and destroys the illusion of a structural form. The blue highlights are a standard convention on a black surface. If the color doesn't suit the character, use gray instead.

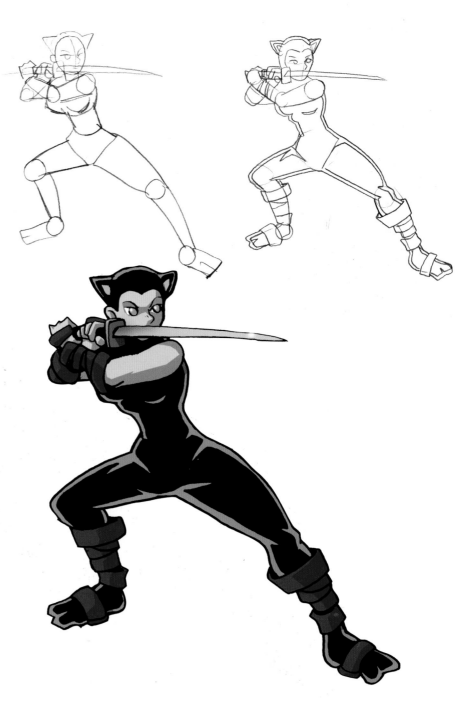

Shuriken Throw

The shuriken or "throwing star" is one of the most famous or infamous weapons associated with the ninja. Throwing stars were traditionally thrown individually, but in the fictional world of cinema, manga and anime, handfuls of shuriken may be launched at a target inflicting a devastating autofire attack.

1 SKETCH THE FIGURE
It's difficult to throw things when you are leaping because you can't brace yourself against anything. The arm is shown at the farthest extent after the throw. Speed lines indicate the velocity and direction of the thrown objects.

2 ADD DETAILS
Set up the details of the clothing making sure you respect the three-dimensional forms by wrapping them around the figure, not just placing them on a flat drawing. Make sure proportions and anatomical details are respected. Even though the character is stylized you should endeavor to maintain the basics of anatomical logic unless you specifically exaggerate a feature such as the eyes or the mouth.

3 COLOR AND SHADE
Color and shade the final image to appear as three-dimensional as possible. Shading and coloring can indicate characteristics of the materials you are depicting. The metallic shuriken are shaded smoothly with clearly defined areas of light and shadow. One way to show movement is blurring objects in motion either digitally or as you are drawing.

Sneak Attack Take Down

The traditional role of the ninja was a spy or assassin, stealthily sneaking into guarded compounds using the cover of darkness. From time to time, guards would be in the way and need to be removed. This is a dangerous maneuver that could result in the death of the guard. Simply sneaking up and pulling them down could result in a loud crash and an angry guard lying on the ground. In this attack the knee is driven into the spine and will support the unconscious guard, controlling the fall. The neck lock could seriously damage the neck and cut off the supply of oxygen. This is a wonderful example of "don't try this at home."

Smooth Finish

The final move would be knocking out the guard or breaking the neck. Denying someone oxygen for a limited amount of time can do severe damage to the brain and injury to the spine. Again, don't try this at home, kids. These manga characters are trained professionals.

1 DRAW THE FIGURES

Be careful with the placement of the feet in the picture plane. Make sure the feet that are lower are the feet closest to the viewer. This is a key stage to make sure perspective works and anatomy makes sense. Fix things at this stage so you don't waste your time drawing the details only to have to correct them later.

2 ADD DETAILS

Lots of small details convince the viewer that the characters exist in a space with its own internal logic. References should be used for some specific details such as the gun and the suit.

3 COLOR AND SHADE

Work to make the characters appear three-dimensional. Make them look different from each other so that you know where one starts and the other ends. Make sure the light source is consistent for both characters and that they appear to exist in the same place.

Armbar Lock and Strike

Much of Taijutsu involves sudden shifts of weight and angling the body to avoid attacks. The other side of it is trapping the opponent and striking. This maneuver is a typical result of years of intense training and a total awareness and understanding of the environment and the opponent.

Keep Multiple Forms Simple

Drawing a combat situation often requires the artist to block in two or more characters interacting with each other. Don't be intimidated. Keep the forms simple and separate from each other.

1 DRAW THE FIGURES
Establish the relationship of the two figures early on. It's difficult to tell here, but the ninja has stepped aside to avoid the punch and has trapped the forearm with his right arm and creates an armbar with his body. He then strikes the back of the attacker's head. It's important to indicate the direction of movement of the attacker and to show the strong, stable stance of the defender.

2 ADD DETAILS
Draw details to reinforce the action. The clothing of the attacker indicates his forward momentum. Showing the results of the action provides the viewer with details that indicate movement without relying on speed lines or other indicators. You can see how vulnerable the attacker has become by over-extending his strike.

3 COLOR AND SHADE
Show creases and folds that help define the shape of the clothing and body as well as the twist and movement of the figure. Avoid making the colors and values too similar. Make sure that each figure stands out.

UNIFORMS AND WEAPONS

Ninjas capture the imagination because of their mysterious nature, their endurance and discipline, their almost superhuman abilities and they look cool.

NINJA UNIFORM

The basic ninja uniform is classic and immediately identifiable. It consists of a black uniform, much like a karate gi. The arms are usually wrapped and the legs are covered in gaiters or wrapped to prevent them from getting in the way of movement and to make less noise when the ninja moves. Extended sleeves hide the backs of the hands. The ninja wears a tabi slipper with a split toe making climbing easier. The soft cotton of the tabi also makes it easier to walk silently. The head is covered in a black hood, making it it easier to hide in the darkness while protecting the ninja's identity.

KUNOICHI, FEMALE NINJA

Female ninja traditionally studied poisons, close combat and disguise. They would often disguise themselves as geisha or entertainers to get close to their targets. They used small, easily concealed weapons such as poisoned needles or they could improvise with shoes or chopsticks with deadly accuracy. This neko (cat) ninja girl is fictional, but is typical of pop culture depictions of ninja.

KID NINJAS

Ninja training started at a young age. The appeal of ninja to youth in pop culture is something that is difficult to ignore. It's surprising that spies and hired killers have become heroes.

NINJA SWORD

The ninja's main weapon is the ninja-to or ninja sword. It is a simple, utilitarian weapon with many uses. It is shorter than the Katana carried by the samurai. It is also of a much lesser quality and has a straight blade. The scabbard can be removed and used as a snorkel device or to block attacks. The wrappings can be used to tie up or trap the opponent.

KUSARI-GAMA

This weapon is made up of a kama or scythe attached to a chain with an iron weight on the other end. Ninjas use the weighted chain to entangle their opponent's weapons or limbs. Balance the details of the weapon with the dynamics of the story. Avoid stiff depictions of any martial art move or weapon use. Try showing the figure in an extreme or frenetic pose.

KAMA ATTACK

The kama is not traditionally swung at the end of the chain to strike opponents as it is not properly weighted to operate that way.

THE ART OF DISTRACTION

Flash powder or clouds of dust and smoke help distract the opponent and allow the ninja to escape. Some ninja kept hollowed out egg shells full of powder that created an obscuring cloud when broken, allowing the ninja to strike secretly or disappear into the gloom.

NINJA CLAWS

Shuko are metal claws used by ninja to help climb surfaces such as rock faces and trees. Shuko can also be used to help block sword attacks by stopping the blade with one hand, absorbing the force of the swing and redirecting the strike towards the opponent. Evasion is a better defense.

INVENTIVE AND DEADLY

The ninja is dangerous with the most mundane objects. Improvised weapons are the cornerstone of ninja success. Chopsticks are strong and easy to conceal. The ninja could target the eyes, temple, neck or various pressure points around the body. The bowl can be thrown or used as a striking weapon.

THROWING STARS

The shuriken or throwing star was originally a dartlike metal blade that was pointed on both ends, but it developed over the centuries into its starlike shape. Shuriken can be thrown or placed in the ground as a trap. It could also be used as a hand blade. Shuriken were not designed to kill, but painfully distract.

On the Move

Indicate movement by showing the wrappings or belt flap in the opposite direction of the movement. Ninja should be depicted as sneaky and unpredictable. This pose shows a twisted figure, concealing the weapon with his body, ready to strike.

91

Tae Kwon Do

Tae kwon do is a relatively modern martial art that was based on the ancient art of tae-kyon kick fighting created some fourteen hundred years ago. By the sixth century a group of trained soldiers called the hwarangdo created a formidable defense force. After the Second World War and the liberation of Korea from Imperial Japan, the art was formalized. In 1955 Major General Choi Hong Hi unveiled what we know now as modern tae kwon do. It has been an Olympic sport since 1988 and it is also the national sport of South Korea. This martial art relies on powerful and creative kicking techniques as well as strong breaking (wood boards, etc.) techniques.

10

WAY OF THE FIST AND FOOT

Tae kwon do is known for devastating kicking techniques and powerful strikes. Practitioners of tae kwon do attempt to increase the power of their techniques through physical training, concentration of force to a small target area, balance and stability, breath control and speed. Downward movement is used to increase the energy of the strike. Scientific application of these concepts allows people of all sizes to dish out impressive amounts of destructive power.

The Five Tenets of Tae Kwon Do

1. Courtesy: selfless acts of treating others with respect and compassion. These acts are done with nothing expected in return.

2. Integrity: strict observance to a stong personal morality or code of ethics.

3. Perseverance: sticking with a difficult task and getting back on that horse leads to ultimate success.

4. Self-Control: this tenet is useful to avoid injury when training or sparring.

5. Indomitable Spirit: inner courage and the ability to overcome personal doubts and fears.

Attention *Ready* *Horse* *Walking* *Front*

Back *Fighting* *Cat* *Cross*

STANCES

Like other martial arts, tae kwon do uses stances as the starting point for all offensive and defensive maneuvers: Charyot Seogi—Attention, Junbi Seogi—Ready, Joochom Seogi—Horse, Ap Seogi—Walking, Ap Kubi Seogi—Front, Dwit Kubi Seogi—Back stance, Kyerugi Seogi—Fighting stance (note foot placement), Beom Seogi—Cat, and Goa Seogi—Cross.

Movement

Tae kwon do kicks include kicks found in other martial arts such as the front kick and the side kick. Despite the predominance of flexible and creative kicking, basic punches or chirugi are also an essential element in tae kwon do. Kwon, after all, is Korean for "fist."

THE VERSATILE FOOT

Tae kwon do has flexible and creative kicking attacks that use many parts of the foot as a striking surface.

BREAKING THINGS

Tae kwon do is known for its impressive breaking demonstrations where boards, bricks and other hard-to-break objects are destroyed. This takes more skill and confidence than physical strength. In martial arts manga, breaking things is often depicted to show the power and danger of the opponent in order to build the suspense and sense of urgency in the story.

DRAW A BALANCED KICK

When depicting a kick, make sure to balance the attacker so they don't appear as if they are falling over. We naturally tilt the torso forward in a kick to avoid falling backwards. Don't forget that the kick is first drawn up towards the body "in chamber" and then snaps out. The higher the leg is raised in chamber, the higher it goes as a kick.

THE FAMOUS KICKS

The roundhouse kick or dollyo chagi is drawn up into chamber and rotates to strike. The back kick or dui chagi is used to strike targets behind the attacker. The jumping back kick or dwee a hoo reu chagi is a difficult kick, but can deliver with the element of surprise. The jumping front kick or the yi dan ap chaki adds height and momentum to a standard front kick. It can be a very difficult kick to master as the kicker is vulnerable when they land. The axe kick or nero chagi strikes the target from above, usually aiming for the head or the collarbone.

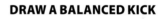

Front Kick *Back Kick* *Jumping Back Kick* *Axe Kick*

Roundhouse Kick *Jumping Front Kick*

Flying Side Kick

The flying side kick is a demonstration of agility, power and acrobatics. The kick would need a running start to execute properly. It takes relentless training to achieve a kick high enough to strike an opponent's face.

1 DRAW THE FORM
The forms should correspond to the anatomy, but notice how the body is twisted and overlaps some of the bent leg. Make sure that the "knife-edge" of the foot is the part that appears to strike the target. Taken out of context this guy seems to be sitting on the floor. Make sure he is drawn in relation to another character or a setting to show how high he has jumped.

2 ADD DETAILS
Add details such as hair and clothing. Don't forget to use them as clues to help describe the action. The hair flying back indicates the direction of movement and the billowing clothing helps complete the effect.

3 COLOR AND SHADE
Color and shade to fill in some details of the folds and creases of the clothing. It looks like he's really flying!

High Kick

To kick this high it is important to chamber the knee as high as possible before kicking. Kicks like this are the cornerstone of tae kwon do.

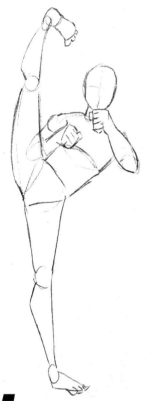
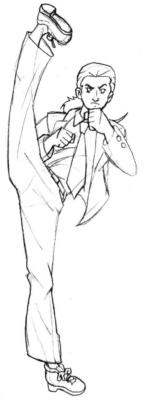

Keep the Guard Up

It is important when raising the leg up into chamber that the hands are raised to defend the body and face. During sparring and fighting it is difficult to maintain this posture when one is tired, injured or distracted. Lowering one's guard at the wrong moment can be disastrous.

1 DRAW THE FIGURE

Ensure the anatomy is correct by "drawing through" the figure. This lets you draw the figure correctly even though other parts will cover elements of the figure. Some indication of details at this early stage of a drawing can really pay off in the end. Notice how the toes are curled back so they don't break when you kick.

2 ADD DETAILS

Make the character identifiable through details. Clothing will crease and billow according to the direction of the movement. Notice how the hair is shown peeking up over the left shoulder. It looks like it's really swinging with the momentum of the kick.

3 COLOR AND SHADE

Use the shading to detail the creases and folds in the clothing. This kick is aimed at the opponent's temple. The figure is depicted leaning back and off to one side to counteract the movement of the leg. The kick uses the ball of the foot as the point of impact. It is important not to turn away from the opponent and to maintain a defensive posture with arms up. With the proper training the legs can be a powerful weapon.

Kick Off!

It's all well and good to draw people kicking at the air. Showing two fighters squaring off against each other makes a lot of sense, especially if you are telling a martial arts story. The trickiest thing about depicting two combatants fighting each other is showing enough details to make them unique and recognizable. Try to show both character's expressions. This draws the reader deeper into the conflict.

1 BLOCK IN THE FIGURES

When you are blocking in the figures it's sometimes difficult to figure out which character is which. Although it may look confusing at first, "drawing through" helps you understand where every part of the character's anatomy should go in relation to the action. This avoids the rookie mistake of having an arm float into frame that doesn't seem attached to any characters.

2 ADD DETAILS

Add details and erase extra lines. A clearer picture of the characters' identities and actions emerges. Overlapping characters is a good way to create a sense of depth. During the character design phase it's a good idea to make sure that each individual has a distinct outline that sets him or her apart from others.

3 COLOR AND SHADE

Clean up the remaining lines and add color and shading to finish the drawing. Choose opposing colors for clothing—warm or cold, dark or light—to make characters that are easily distinguished from each other.

Breaking Things

Unfazed by the breaking of mere wooden boards, some martial artists like to prove their worth by breaking concrete paving stones or bricks. The approach is basically the same no matter what material is being broken. The key is in the velocity of the strike, not the physical strength of the martial artist. Breaking is a form of conditioning the body to build up resistance against physical damage, but it can cause long term injury.

1 BLOCK IN THE FORMS
Don't forget how helpful "drawing through" can be when you block in your figure. Even though the slabs of granite are in front of the back leg, the back leg is drawn so that we can understand the character's relation to the blocks and the ground at his feet. Notice that the heel of the palm is the point of impact to break the slabs.

2 ADD DETAILS
Draw the hair and clothing trailing after the figure to indicate the speed of the strike. Much of the break depends on speed, but striking down like this also makes use of gravity and the weight of the slabs to achieve a break. Pointing the feet inward toward the center of the figure uses back muscles, not just the arm, in the strike.

3 COLOR AND SHADE
Know where the light source is in relation to the figure and props. The face is in shadow and the shadow of the slabs and blocks is also cast on the ground, indicating depth. Different materials break in different ways. Wood tends to splinter as it breaks. Stone and brick disintegrate into smaller pieces and sometimes a cloud of dust.

UNIFORMS AND EQUIPMENT

Tae kwon do is a fairly recent addition to the martial arts world. As such, the uniform is less bound by tradition and more functional. Weapons and equipment have been adopted from earlier Korean marital arts. When depicting clothing and gear it's a good idea to find reference material. Ideally, sitting in on a lesson or actually trying out the martial art is the best way to learn how to draw it.

Tae Kwon Do Advancement

Tae Kwon Do training is regimented. A checklist of skills is demonstrated at a grading and a belt is rewarded. There are ten "junior" ranks or Kups. Common belt colors are white, white with yellow stripe, yellow, yellow with green stripe, green, green with blue stripe, blue, blue with red stripe, red, red with black stripe and black. Beyond the black belt or tenth degree are rankings called Dan. Promotion from one Kup to the next can take a few months and promotion from one Dan to the next can take years.

UNIFORM

The basic uniform for tae kwon do is a heavy cotton uniform similar to a karate gi, but notably different with a black edging around the neck. The design of the gi is also unique because the top is pulled over the head and worn as a V-neck and is not an open top. Fourth Dan and higher practitioners can wear white pants with a black stripe down the side.

FULL CONTACT WITHOUT RISK

With an emphasis on powerful kicks, sparring in tae kwon do can be dangerous. Protective gear, including full torso padding, allows combatants to make full contact without as much risk of serious injury. Stories of character training or competitions will probably need to show some form of protective equipment.

FLEXIBILITY

Uniforms in tae kwon do should allow a wide range of flexibility and stretching as the style focuses on kicking.

THE CANE

Traditional Korean weapons training is called han kuk muki do. The weapons are similar to those found in other martial arts. The ji pange or cane is used as a short staff and allows the user to trap or trip the opponent. This is a particularly appropriate weapon for elderly or injured characters.

KOREAN SAI

Jang tan-do are Korean Sai. They are usually unsharpened and are primarily used to defend against and trap weapons. As an offensive weapon they are usually used as a blunt metal object.

THE NAT

The traditional Korean sickle was used to harvest crops. As a weapon it is known as the nat. When you are drawing the nat, don't forget to show that the handle and the blade are made from different materials.

TONFA

The tonfa are also used for defensive blocking, traps and holds as well as strikes. The longer part of the weapon protects the forearm and the end of the short side is used to strike.

MATERIAL FOR BREAKING

Breaking concrete blocks and slate demonstrates the power and dedication of the martial artist. When drawing material such as concrete, stone or brick, consider the surface texture and details.

THAN BONG

Two small sticks for fighting can be very effective weapons, usually aiming at weak points such as the head, neck, solar plexus or stomach. They are also devastating against nerve and pressure points. The small sticks can also block other weapons without injury.

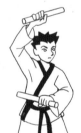

TWO-SECTION STICK

The Korean version of the nunchuka are the ssahng jeol bongs or two-section stick. It is used to sweep areas for defense and inflict a devastating strike.

JUNG BONG

The Jung Bong or Middle Staff is used for blocking and quick strikes.

JANG BONG

The Jang Bong or Long Staff is used much as in other martial arts. It provides a chance to put distance between opponents.

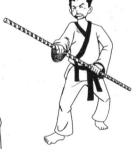

Wire Fu

Wire fu is not a traditional martial arts form. It is more of a theme or genre of martial arts that has appeared in movies and television shows that have borrowed heavily from Hong Kong action films. The genre is called "Wire Fu" because of the improbable acrobatic flips and gravity-defying leaps that the actors appear to make with the help of a harness and wires. The inspiration for these abilities appears to come from the literary tradition of Wuxia in China. This fantastical subgenre of martial arts action stories is a combination of Xia, an ancient code of honor, and wushu martial arts history and legend.

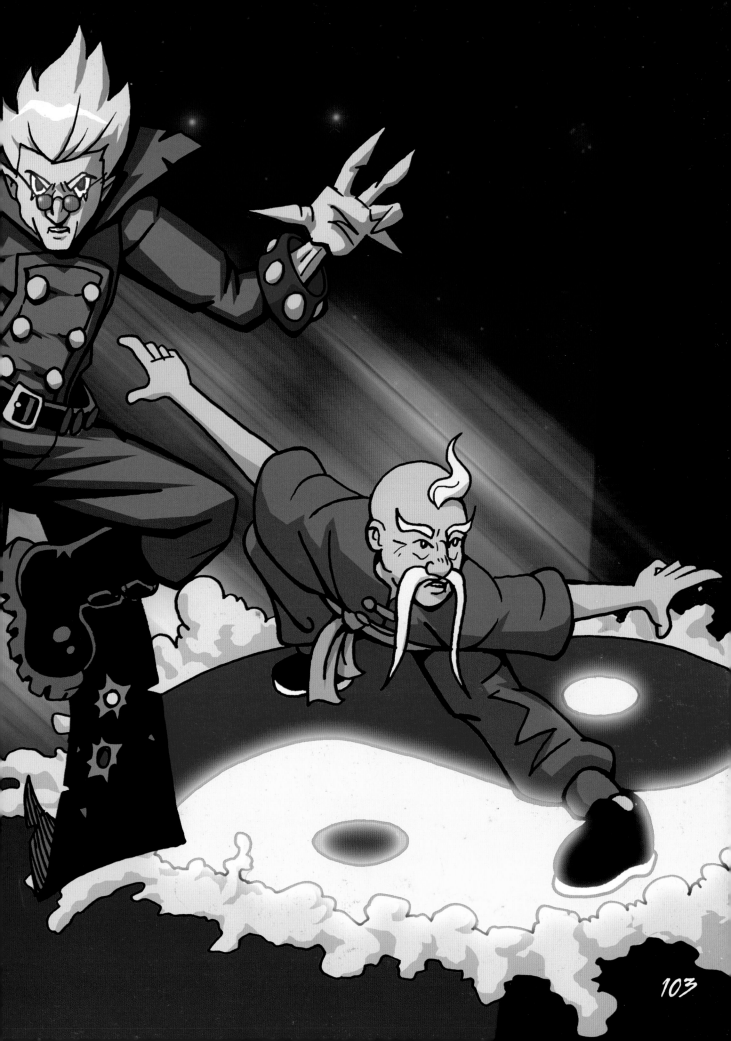

LIGHT BODY SKILL

Actions such as skimming the surface of water, scaling walls or trees with ease and leaping tall buildings with a single bound are inspired by stories of qing gong or "light body skill." This is a real ability using ramps and sandbags to increase physical strength and control, but in the hands of wuxia writers and wire fu filmmakers it has become a superpower. More recently wire fu has infiltrated mainstream Hollywood action films and television programs. The exaggerated action is quite at home in the medium of manga.

Wuxia is Ancient History

Originating as far back as the second or third century BCE., wuxia stories of the Warring States era of China's history captured the imagination of readers presenting outlandish, loner heroes performing impossible feats of physical action. The Chinese Communist Party initially censored modern wuxia fiction, but the ban was lifted in the 1980s. Wuxia has remained popular to this day with a revival of fans discovering the genre on the Internet.

FLYING WARRIORS

Although it appears as if wire fu warriors can fly, it's actually that they can control their weight densitiy. They can make themselves monstrously heavy and immobile or alternately they can become light as a feather and travel great distances in an elegant flitting motion.

EXTREME STANCES

Wire fu often uses stances and styles seen in kung fu and wushu. Stances are shown as the most extreme and exaggerated as seems humanly possible.

CONTROLLING MYSTICAL ENERGY

Neijin, or the art of controlling mystical qi energy, can be used to enhance attacks and defense to the point of the superhuman. Dim mak is the knowledge of manipulating pressure points on the body for potentially deadly results. Wire fu turns dim mak into a "death touch" and even goes so far as to have characters launch bolts of energy out of their bodies.

Movement

Make sure you really embellish all the action in a wire fu story. Some would argue that all comics should use dynamic, over-the-top feats to depict action. This makes sense with the medium of manga and comic books as many wire fu movies were inspired by stories that originated as a visual medium.

EXTREME MOVEMENT

One way of showing extreme movement and action is to draw multiple images of the same character in various poses in the same drawing. Action lines describe the movement of the character.

KICKS CAN BE MORE THAN KICKS

The entire landscape can be utilized to fight a battle. Wire fu characters bounce off the floor, walls and even the ceiling in the midst of a confrontation.

SHOWING A PATH OF MOVEMENT

Lightly repeating the object shows a path of movement and gives a slow motion action effect to the panel.

IMPACT BURSTS

Impact can be indicated with a flash or burst. Although we wouldn't really see this kind of flash in real life, it seems to make perfect sense in the world of manga and comic books. The nice thing about showing impacts this way is that the reader can see exactly what was struck and what hit it.

MULTIPLE FAST STRIKES

Drawing the hand multiple times and blurring out the character's arm can show multiple fast action strikes. This gives the impression of quick, successive attacks.

Flying Fists Of Fury

OK, so it's an open hand strike, but you get the idea. This kind of long distance qing gong gliding strike is everywhere in the wire fu genre. Two combatants leap into the air at the same time and meet halfway unleashing a barrage of lightning fast attacks. They then land and the results of the battle are revealed, one of them falls over and the winner steps away triumphant.

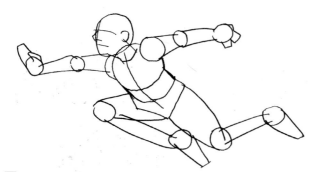

1 BLOCK IN THE FIGURE

Block things in fairly roughly at this stage and don't be intimidated by the complexities of the pose. Focus on making sure the anatomy is correct and the structure is clear. The trick is making it look like flight as opposed to a jump. Sometimes in the movies, the characters will "pedal" their legs in an attempt to propel them further.

2 ADD DETAILS

Add details of the clothing and anatomy. The flow of the clothing/sash and the hair/mustache show the speed and direction of the warrior. Notice how the extra hands fade off into nothing. This reinforces the fact that the attacks are almost too fast to see.

3 COLOR AND SHADE

Finish off the drawing and sink it into the setting. The shading of the extra arms is fading off, again reinforcing the apparent speed of the strikes. If you are using a computer to digitally color your work, you may even be able to blur or fade these extra hands to add to the effect of fast movement.

Foot Drag Block

The foot drag block is another classic wire fu staple. The attacker launches a furious assault and the defender raises their hands to absorb the impact. Attempting to maintain a strong solid stance, the defender is pushed back, often through walls and other obstacles in an attempt to withstand the attack. This sort of meeting of the masters can create quite a shockwave and unleash thousands of dollars of collateral damage.

1 INDICATE THE STRUCTURE
The pose needs to be drawn quickly and clearly at this stage so make sure the details that express the ferocity of the action are indicated. The furrows dug into the ground by the dragging and the shockwave are indicated at this stage. These artistic elements should be included early as they are just as important as the anatomy and action being depicted. Ignoring them now can create a rushed or fudged look when they are added in later.

2 FLESH IT OUT
Vary the thickness of your lines to create a more convincing image. Line is used to define form. Thick line is used in areas of shadow and thin line is used to show areas of highlight on the figure. Notice that the sleeves of the leaper are disintegrating. This might be an indication that the attack is failing and the vampire's chi energy might be more powerful in this contest. The ground appears to be buckling and chunks of dirt and concrete are tossed into the air behind them. Digging in one's heels also seems to kick up a lot of dust.

3 FINISH THEM!
Leave the shockwave white to avoid any confusion that it might be some kind of energy or blast. It also would draw attention from the drag effects. Wire fu is all about showing off and special effects so don't be afraid to really go over the top. Some readers would argue that all manga should be drawn in the extreme wire fu style. This dynamic style can be flashy, but really doesn't suit all stories, just as it doesn't suit all martial arts movies.

Extreme Flying Kick

The rules of physics and gravity seem suspended in wire fu. Characters are able to leap and strike multiple times. It's even possible to twist and contort in the most implausible and unusual ways. This pose for example depicts a desperate kick from a very unusual angle. Wire fu tries to depict the most extreme action imaginable.

1 BLOCKING IN THE FIGURE

Block out the pose using structural forms. Experiment and push the boundaries of standard poses and action. In this case, try to anticipate the way the figure will contort. Don't be afraid to block in key details such as the tails of the coat. If it isn't working, it can be modified or even abandoned for another approach. Skipping this step and trying to make the drawing look "finished" from the start runs the risk of having proportional errors and makes it harder to abandon.

2 TIGHTEN THE IMAGE

Ink and carefully erase the underlying drawing. The pose is very challenging and much is hidden because of the foreshortening and the fact that objects or body parts are in the way. Failure to erase the pencil isn't necessarily a bad thing, it just makes it difficult to tone or color in the end.

3 COLOR AND SHADE

Indicate the colors and values at this stage. Consider the textures of the objects shaded, such as reflective hair, shiny leather or a jacket with stains. Extreme action can appear unrealistic so make every effort to shade and color the image in a convincing manner.

Concentrated Chi Blast

This special wire fu attack is more in the realm of superpower than reality, but it is quite common in martial arts manga and video games. Essentially it is a buildup of bioelectric energy concentrated into a blast that is then launched at the opponent. Most often this energy leaps from the hands in a style that is similar to dragon style kung fu.

1 SKETCH THE POSE

Visualize and sketch the pose, "drawing through" to make sure the shoulders are not cut off or distorted. Note that the hands appear bigger because they are closer to the viewer. This kind of foreshortening is useful to create more dynamic poses and action scenes. It almost appears as if the bolt of energy will whip right past our ear. Don't forget to make poses dynamic. Depict the pose at the most dynamic point of the action. This figure is crouched and the spine curve is indicated with a curved line.

2 CLEAN AND ADD DETAILS

Clean up the artwork and erase the underlying pencil lines. Note that the line thickness helps indicate the proximity of what is drawn. Closer hands have thicker outlines while the rest of the figure is drawn with slightly thinner lines. This helps reinforce the illusion of depth in the drawing.

3 COLOR AND SHADE

Obviously this image benefits from the use of Photoshop to create the special effects of the chi ball glowing. To make this image even more dynamic the energy ball is used as the light source. Shadows indicate the direction of the lighting and the glow lightens the dark lines around the fingers. Notice how the wind also seems to be blowing from the energy ball, whipping the sash and blowing the hair back.

UNIFORMS AND WEAPONS

Wire fu often employs loose clothing that is often bound or tied back to allow a wide range of acrobatic movement. Flowing fabric makes for a great visual trail after a flying round-house.

Wire fu also uses objects not immediately thought of as weapons such as feathers used as throwing daggers.

ELEMENTS OF PAST AGES

Many wuxia movies are set in the past and are referred to as costume epics. This costume has elements of the Qing or Manchu dynasty (1644–1912), especially the pony tail and the shaved forehead. The ruling Manchu made the indigenous Chinese adopt this cultural fashion as a symbol of submission to the invaders. Those who refused to wear their hair in this fashion were put to death.

SORCERER OR FIGHTER?

Supernatural and futuristic elements are often used to explain the origins of wire fu powers. Wire fu doesn't always rely on chi power, sometimes it's magical abilities or high tech gadgetry.

HEROIC ACTION

Modern wire fu stories have much in common with comic books and super heroics. Elements of the martial arts genre have crossed over into super hero comics before. Manga has followed the training and adventures of various super ninja characters over the years. Comic book artists have even been used to create storyboards for action sequences for movies such as *The Matrix* and *Underworld*.

Express Yourself

It's important to understand what has gone before you in order to help identify your style and genre, but it's what you add to the artwork or story as an original creator that makes it interesting and honest. Great technical artists could mimic the style of Hokusai or Picasso and create amazing artwork, but that isn't original expression, it's an impression. True creativity comes from blending elements that have not yet merged. Ask yourself, "What original idea do I bring to my artwork?" Don't be a copycat; you'll miss some wonderful opportunities to express your individuality.

HIDDEN WEAPONS

Unusual weapons such as an iron fan add color and character of the wire fu genre. These weapons, disguised as everyday objects, add an element of surprise to the attack.

IMPROVISED MAYHEM

Using everyday items as unexpected improvised weapons is a standard element of wire fu. It can be fun to see what mayhem can be unleashed with everyday objects.

ENCHANTED SWORDS

Flashing swordplay is often a key element in wire fu stories. Swordfights are acrobatic and cover a large geographic area, often leaping from rooftop to rooftop and crashing through obstacles in the way. Weapons are treated as extensions of the body and are fully integrated into martial art techniques.

THE ULTIMATE WEAPON

The inner chi energy that can be unleashed as mystical bolts or fireballs is the ultimate demonstration of wire fu abilities. These blasts are standard fare for popular fighting manga, anime and games. The key to using them in a story is to focus on the intense training and discipline required to use this power.

AMAZING HEROES

Wire fu is even at home in traditional fantasy stories where heroes perform almost super-human feats. Amazing heroes have been stomping dragons since the first stories have been told.

That's Gotta Hurt

The intense impact of a blow is the result of all the meditation, training, forms, practice and sparring. Ultimately when characters learn to turn their bodies into deadly weapons, they end up using them as deadly weapons. The key to drawing all of this martial arts mayhem is to decide how far you will go in depicting the inevitable violence of the battle.

112

CONFLICT AND INJURY

All stories require conflict, and despite the best intentions and pacifist tendencies of Eastern philosophy, the end result of a martial arts battle is somebody getting hurt. It's amazing how fragile human beings truly are and despite endless conditioning and training we can easily be reduced to a crumpled heap.

Reality Check

In real life, strikes, falls from short distances and even standing can cause serious injury, even death. Broken bones, bruised organs and bleeding can all result from a fall or a strike. Hitting someone can also injure the attacker. Boxers often break the bone behind the fifth knuckle. Fists are much less able to deal with impact than the human skull. The skull is designed to take some impact, the fist isn't so lucky.

UNCONTROLLED FALL

The figure should hit the ground and flatten out. In this case, landing on the shoulders and back, the legs are still flailing as the character strikes. The arms are in different poses, indicating that the fall was out of control. Action lines imply the direction of movement and the speed of the fall. The impact burst on the ground shows the force of the impact. The harder the impact, the bigger the burst.

STRENGTH BEFORE DEFEAT

Showing the flexibility and strength of the human body in movement is important before the reader sees the agony of defeat. Make sure the figure appears to be in control and graceful. It's a good idea to watch gymnasts and acrobats in action.

CONTROLLED FALL

When you are drawing a controlled fall, make sure the figure has the weight distributed evenly. Puffs of dust, dirt or snow should be kicked up indicating that the character hit the ground with a certain amount of force.

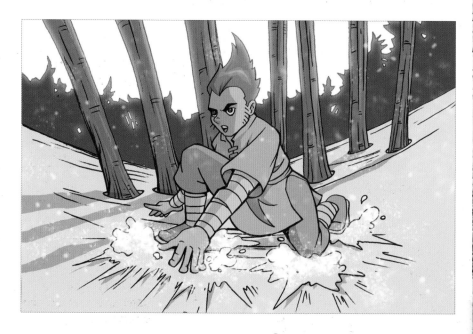

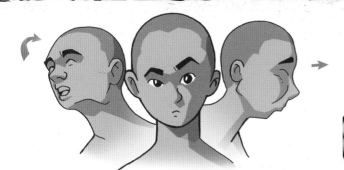

STRUCK HEAD

When the head is struck by a punch or a kick, it will snap back and/ or to the side depending on the angle of the attack. The neck allows for some range of movement, but the large mass of bone, muscle, tendon and soft tissue limits the arc of head rotation. Make sure the head moves away from the angle of the attack and not towards the strike.

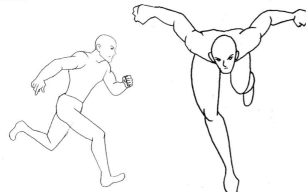

FROM IMPASSIVE TO INTENSE

Instead of showing action from an impassive, matter-of-fact perspective, try increasing the intensity by making the pose more dynamic. Making the image more dramatic adds intensity and action to the story. Like a movie director you have to make decisions about how the image will be understood by the viewer/reader. The more dynamic the art, the more dynamic the storytelling will be.

DYNAMIC KICKS

Drawing dynamic kicks can be fun. Notice how the leg is foreshortened with the closest part appearing larger as it approaches the viewer. The foot is big and in your face. The head centers itself over the foot that supports the weight of the figure. The head is often the key to understanding which foot is supporting the weight of the figure.

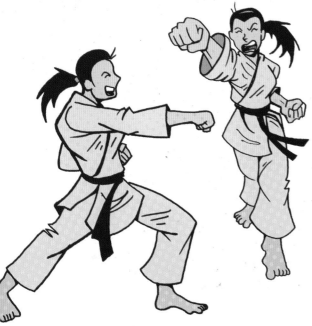

BALANCE ACTION AND DRAMA

Throwing a punch should be depicted using proper form, but it can be dramatic too. That said, make sure you choose an angle that drives the story forward and is not too confusing. Use images and angles that are clear enough so the reader understands what's going on in the image. Don't ignore the balance between style and substance.

Be Your Own Critic

Make sure your pose is the best image to drive the action of the story. If a simple side view kick is appropriate, use it, but don't forget to switch up angles so the images don't appear too static.

A HIT, A PALPABLE HIT!

When characters get hit they shouldn't just stand there. The whole body moves in an opposite direction to the strike. Powerful manga characters can toss their targets around the battlefield with attacks of incredible force. Showing the result of being hit using body language helps create dynamic storytelling. It's cause and effect!

TO THE CHEST!

A strike just below the chest, to the solar plexus or stomach, often causes the victim to lean forward, bending at the waist. This takes the victim down right about where they are standing.

TO THE FACE!

Showing a punch to the face can be embellished in many ways. The impact starbust shows the point of impact, where the fist hits. Notice that the head has snapped back, off the angle of the body from the original point of impact. The cheek, being a soft and fleshy part of the face will ripple and push in after being hit. This is a split second effect, but the result is dynamic and evocative. Looks like it'll leave a mark.

Sometimes It's Too Real

Showing the results of bone-crushing impact can vary depending on how realistic you want your manga to be. People who are really hit in fights can be seriously injured and even killed. There's no coincidence that every martial art promotes the use of protective gear when sparring. If you get hit, you get hurt. Once again, don't try this at home!

BODILY REACTION—FACE

The whole body will move around a bit more when struck. Punching the head or face only will send the body falling backward, almost knocking the feet out from under the victim depending on the force. Again, an irregular burst indicates the point of impact.

BODILY REACTION—CHEST

When the chest is hit, the entire figure is knocked down. Surefooted individuals may stumble back a bit before falling, but the weight of the body will send the legs flying upward and the victim will fall on their bottom or lower back. The arms may naturally shoot out to the side to catch the fall. This kind of knock back can send an opponent flying several meters.

WHY HAVE JUST ONE?

Sometimes just one punch per panel won't do. In those cases, showing multiple attacks is as easy as drawing the hand striking again and again. To reinforce the fact that these are after images of a super fast punch, you can fade out or blur the extra hands and arms. The impact stars point in the direction of the energy as it is expended. How would you block that barrage?

BIFFED!

Notice that an upward punch to the chin makes the head arc backward and down to the back. Blood and spittle often fly up in the direction of the original strike.

A punch to the side of the face rotates the head in the opposite direction of the strike, but it can also turn the entire body before the figure falls down.

MULTIPLE STRIKES ON TARGET

This can prove trickier. To solve the problem, you can draw the victim once, reacting in pain and distress with multiple impact stars that indicate the points of contact from the punches or kicks. Making some impact stars bigger than others denotes a range of energy. Large stars are stronger, smaller stars are weaker.

SHOWING A FINAL LOCATION

Making only one leg and foot appear attached to the body gives the reader a pretty good idea of the final location of the leg at the end of the strikes. That's some fancy footwork.

SHOWING EFFECTS

There are many ways to show the physical effects of being hit, and they are relatively easy to convey. The state of mind of someone who has been hit, or to depict a feeling such as pain, requires a visual shorthand unique to manga, comics and animation in the form of stars, birds and other woozy objects.

BLACK EYES AND BRUISING

These are another quick indication that the character has been hurt. Often bruises don't turn dark all at once. They often appear red and then purple as the blood vessels break under the skin. As the bruise heals, it will turn from bluish-black to greenish yellow before it goes away. The bandage may appear immediately after a strike in less serious manga and comics.

USING BLACK FOR BLOOD

To show that someone has been hit in the face, drawing a bloody nose and lip is a dead giveaway. To lessen the "gore factor," don't be afraid to fill in the blood with black instead of red. Small double lines can indicate areas of bruising or scuffs and scratches.

SPOILER FACE

This image shows someone who has been hit and although they are trying to hide the fact that they are in pain, the clenched teeth, wide eyes and tears streaming down their cheeks area tell that they are in some serious hurt.

GOOSE EGG

A small bump on the head can even be drawn as this manga shorthand for a raised vein on the temple. Detailing it a bit more can reveal a more painful, swollen injury.

SLAP HAPPY

Slapping the face can produce a red hand-shaped mark. This mark can appear anywhere on the body. Combined with a reaction look, this can create a very humorous image.

ROUGH DAY

When the injuries are more serious, it's easy to see that it hurts. One eye is swollen shut and bruised. The cheekbone swelling has turned an angry red. The lip is swollen, red and puffy. The nose, if broken, can appear flat against the face at an odd angle.

REALLY ROUGH DAY

Someone who is severely beaten may have multiple "goose eggs," all swollen and red. The eyebrow and scalp bleeds easily and profusely and when the blood runs into the eyes it can painfully and temporarily blind the victim. The nose bleeds when struck, the cheeks can puff up and bruise. The lips swell up and split easily. Teeth are easily knocked out and can further cut the inside of the mouth. This guy is a mess.

CHANGING THE FLAVOR

An image of skulls circling the head is a bit more unique and could show what's been hurt or make a comment on the injury. This could possibly indicate more life-threatening damage. Replacing the skulls with slices of cake or flames could give a different message about the wound.

SEEING STARS

Taken literally, you can draw the character as actually seeing stars. This is a little more "cartoony" and less serious, but it's right at home in the medium of manga and comics. Drawing the eyes as spirals also reinforces that the character has taken quite a hit to the head.

CHIRPING BIRDS

There's always that old convention of birds flying around the head and twittering. This probably originated from early animation and it has a certain disarming charm.

SMARTING

Stars and wiggly lines emanating from a location are comic shorthand for pain or injury.

SEEING SPOTS

Seeing spots or lights is common when the optic nerve has been knocked around. Little light trails are simply the optic nerve firing and tricking the brain into seeing flashes.

Storytelling

Storytelling is the ultimate goal of creating manga. Many elements of visual storytelling are shared by manga and filmmaking. "Camera" angles and shots, panel pacing and composition all work together to reveal the story. Manga pages are not the same as newspaper comic strips. The entire page of individual panels is often composed to help tell the story and "read" as a single unit. It's all well and good to draw these crazy characters, now it's time to give them something to do!

DYNAMIC PAGES, DYNAMIC STORIES

Manga pages are not simple comic strips. Each panel should flow into the next, driving the story and leading the reader across the pages from one image, word balloon to the next. Static pages such as this are common for people just starting to make manga or comics.

Eight Elements of a Martial Arts Plot

1. Learn the lost art from the grumpy master.
2. Avenge the death of the master/brother/sister/father/uncle, etc.
3. Defeat the nemesis who just might be your long lost brother/sister/mother/father or eventually join forces to defeat the real nemesis.
4. Over-the-top sound effects for every action the character makes.
5. Cheesy dialogue: "My kung fu is stronger than your kung fu."
6. Mistaken identity often has two heroes battling each other for half the story until they realize they are fighting a common enemy.
7. One technique is learned to defeat another technique and is used just in time.
8. Everyone knows martial arts!

PITFALLS OF STORYTELLING

The problems with this comic page:

- The characters are the same size from panel to panel with no variation to show drama or emphasis.

- The same pose is repeated from panel to panel with the ground below and a slight variation to the background. This creates a "side-scroller" effect similar to early video games.

- Cutting and pasting panels with the same image may buy time, but they do nothing to add to the storytelling. A simple similarly sized panel page can be used to show the passage of steady measured time and create a real pace and flow for a story, but it's a wasted opportunity to use creative layouts and panel combinations.

USE A VARIETY OF ANGLES, DISTANCES AND PANEL SIZES

The closeup and large sound effect of the first panel creates tension for the reader. The diagonal elements add to the anxiety. The next two panels, shown from above, give the figure a sense of inferiority. Looking down on him, he appears weaker and smaller. The image is also on a tension-creating diagonal. The panels are revealed to be the point of view of the creature near the ceiling which helps draw the viewer into the story. The final panel is an "over the shoulder" image that reveals the monster climbing the walls in a very inhuman way. Again, the diagonals create tension and drama. The dramatic shadows make the monster look bigger and more mysterious. Showing the scene over the shoulder also gives the characters a chance to react.

Variety is important. All the points of view vary from panel to panel. Changing panel size, angles and points of view makes the reader stop and reassess what is going on, controlling the speed at which the reader progresses. Readers tend to linger on larger panels and jump quickly over smaller panels. Avoid putting extra dialogue or sound effects on the panel if it is the focus of the page. A picture can say a thousand words.

SHOWING COMBAT

This combat sequence breaks down the main points of action into panels. Each action is depicted in a dynamic, but clear way. Each movement is also accompanied with a sound effect to accentuate the action. The lights and darks help identify where the viewer should look on the page. The action lines in the first two panels are brighter than the surrounding images. The third panel has a strip of shading across the center, drawing attention to the movement of the elbow. The area around the point of impact is also the brightest point in the panel. The programming cards flying out of the head of the robot flutter off the panel and into a dark background. This elegantly ends the combat sequence and slows down the action with a poignant and lyrical image that leads into the next sequence.

The Big Fight

The Impressionist artist Edgar Degas said that works of art should be as carefully plotted as the perfect crime. Failure to plan ahead when creating a manga page creates something that looks cluttered, hard to read and rushed. Drawing thumbnails and sketches gives the artist an opportunity to take advantage of ideas that can occur spontaneously once the images are on the paper.

You're In Control

Don't be afraid to move elements of the page. Arrange them to control eye flow. You can speed up or slow down the reader depending on the variety, detail and size of the panel.

1 MAKE THE THUMBNAIL

Make a quick, intuitive drawing to get a handle on how the action will be depicted as well as how the reader will move from panel to panel. Trust your instincts and make the panel shapes as unique as possible to tell the story. Don't be a slave to the grid pattern. Manga is known for it's loose and open-concept panel layout. Unlike true manga, this image is designed to read left to right, like this book.

Figure out where the text balloons will go in the end. It will help you, in turn, figure out what you're going to draw. It makes no sense adding detail to an object that's going to be covered up with a word balloon. The arrows show how the eye can be lead through the entire page.

2 PENCIL

Use a small X in a negative space that will be colored in black during inking. Filling in with pencils would be too smudgy. Use a ruler for the lines and ellipse stencils for the word balloons if you have them. These word balloons were drawn freehand, but will be cleaned up in the inking stage using a stencil.

3 INK

Tighten up and finish the drawing in ink. Make sure you use a variety of line widths and choose your pure black areas carefully to move the eye around the page from panel to panel. Strong contrast attracts attention. The differing speed lines in the third panel help add depth to the background. Add lettering now or add it later digitally.

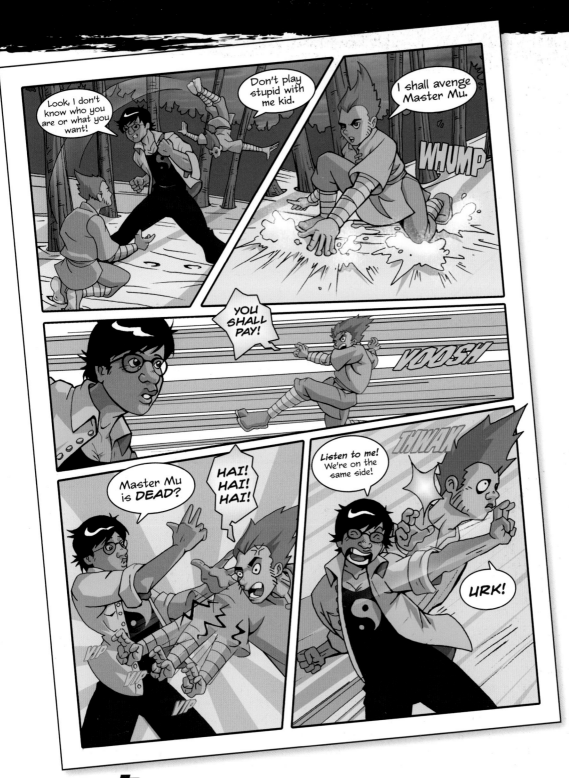

4 ADD COLOR AND LETTERING

Most often, manga is not color. It's traditionally published in black and white with some dot tone to indicate textures and shading. This trend has changed over recent years with more and more manga moving to colored.

Digital programs can produce helpful effects: the sky in the first two panels was taken from a photograph I took looking out my front door at a sunset. The powdery snow was done with a special digital brush on top of the finished color artwork. It adds a sense of movement and impact. Make sure you don't use digital effects as a crutch. The images should be readable without the fancy colors. If they are, then you'll have done your job as a storyteller.

Conclusion

Don't forget that depicting martial arts action in manga is about keeping the images dynamic and interesting. This book is designed to help artists understand the unique characteristics of a variety of martial arts styles. The artist should build upon this knowledge and create new and exciting ways to depict the action.

This book was inspired by many important teachers in my life, my love of martial arts and my frustration that a stand alone resource didn't exist as a reference guide for artists.

The ultimate depiction of martial arts in your work will be determined by what effect you are trying to convey. If you are attempting to show gritty realism, then keep the moves basic and the effects dramatic. This is more about tone than anything and is ultimately determined in the writing stage of the story. If you are trying to emphasize action and adventure then you can be a little more acrobatic and dynamic depicting extreme maneuvers and exaggerated movement.

Understand the dynamics of anatomy and construction drawing, but realize the limits of the human body. Flashy attacks may be fun to draw, but they might not make as much sense when you are trying to depict a real life martial art. It never hurts to actually study a martial art. You'll gain insight into the heart and soul of the style and get some exercise at the same time. Nothing beats muscle memory when you are trying to depict a particularly complex maneuver.

Your manga characters are your actors and your stuntpeople, but ultimately the artist is the director. As director, it's up to you to tell an interesting story that is easy to understand, but interesting and exciting to look at. Avoid the side-scroller approach to storytelling, change the "camera" angle for each panel to make the action even more visually exhilarating. Suck the reader into the action by varying the point of view and camera distance, alternating close ups with long shots. In short, try to make your martial arts manga as dynamic as your favorite martial arts movie.

Have fun and try to challenge yourself with each image.